CARTOONS & CORONETS

The Genius of Osbert Lancaster

CARTOONS & CORONETS

The Genius of
OSBERT LANCASTER

Introduced and selected by
JAMES KNOX

F

FRANCES LINCOLN LIMITED
PUBLISHERS

This book is published to coincide with the Exhibition at the
Wallace Collection, London, *Cartoons & Coronets: The Genius
of Osbert Lancaster,* designed by Charles Marsden-Smedley
(2 October 2008 – 11 January 2009)

Conceived and assembled by Virginia and John Murray

Photographed, scanned and laid out by John Murray

Designed by Octavius Murray

First published in 2008 by
Frances Lincoln Limited
4 Torriano Mews
Torriano Avenue
London NW5 2RZ

www.franceslincoln.com

ISBNs
hardback: 978-0-7112-2933-4
paperback: 978-0-7112-2938-9

Printed and bound in China

CONTENTS

All illustrations are by Osbert Lancaster unless otherwise attributed
and are from original artwork wherever possible

For Virginia
archivist and chatelaine
of 50 Albemarle Street

PREFACE

In his heyday, Osbert Lancaster was one of the foremost artistic personalities of his generation, renowned as an architectural satirist, cartoonist, theatrical designer, dandy and wit. And yet within ten years of his death his widow Anne lamented to James Lees-Milne, 'Osbert's work is forgotten now.' His brilliance as a pocket cartoonist contributed to the speed of his eclipse, as he himself had predicted: 'nothing', he wrote, 'dates so quickly as the apt comment.'

This book sets out to uncover the riches of his life-time's work. These range from his influential architectural satires, which introduced styles such as Stockbrokers' Tudor to the critical canon, to his acclaimed stage and costume designs for Covent Garden and Glyndebourne, and to his illustrations, visual parodies and jokes.

The cartoonist 'Matt', of the *Daily Telegraph*, is convinced that the time is ripe for a revival: 'What amazes me,' he writes of Osbert's cartoons, 'is how sharp and relevant they still are. You can admire the work for its draughtsmanship, social commentary and attention to detail, but I am most impressed by his marvellous wit and the amazingly high standard of his jokes.' That fine draughtsmanship, wit, eye for detail and historical sense of his cartoons can be seen throughout all his other work, making it truely exceptional.

This accounts for the smile of recognition that so often greets the mention of Osbert's name. Yet until now there has been no opportunity to assess his overall artistic achievement, which will come as a revelation both to past enthusiasts and to those unfamiliar with his work.

I am especially grateful to Anne Lancaster, Cara Lancaster and her brother William and to Clare Hastings for their continual assistance and support. I would also like to thank Julia Aries of the Glyndebourne Archive, Julia Creed of the Royal Opera House Collections and Andrew Mussel of Lincoln College, Oxford as well as Octavius Murray, John Craxton, Stephen Hebron, Davina Howell, Caroline Knox, John Saumarez-Smith, Katherine Lambert, Janey Kinnersley, Rebecca Parker, Grant McIintyre, Diana Murray, John Powell and Matt Pritchett.

Without John and Virginia Murray this book would never have been written, let alone produced. Virginia's command of the archive and sure eye for the best illustration have been invaluable. John conceived the design, developed the blueprint and put the book together. His unstinting support, enthusiasm and dedication have matched Jock Murray's care of Osbert. As such, he is a true Murray, one of a family who over seven generations have always done their utmost to benefit their authors past and present.

THE MAKING OF OSBERT

EARLY DAYS

In his memoir of his childhood, *All Done From Memory,* Osbert Lancaster, a connoisseur of social distinctions, classified his own family as the 'old upper-middles' of nineteenth-century England, whose culture was essentially metropolitan and Anglican and included artists and writers as well as 'eminent KCs [King's Counsels] and the Masters of City Companies'. This class was already in the process of dissolution by the time of his birth during the reign of Edward VII. However the Lancasters proved immune to change, so that 'in the halls of my youth', he wrote, 'this small society upheld the standards of that period…'

The embodiment of these values was the head of the family, Osbert's paternal grandfather Sir William Lancaster, whose career had been a typical success story. Descended from 'manic depressive yeoman farmers' in Norfolk and brought up by his widowed mother in relative poverty in King's Lynn, he determined to reverse his family's decline. He left in his teens for London, joining in 1858 the fledgling Prudential Assurance Company. Within fifteen years of his arrival the firm had grown from five employees to eight hundred. William's fortune grew accordingly, allowing him to take up residence in 'a large four-square Victorian mansion in yellow brick' on Putney Hill. This imposing house, fronted by a circle of impeccable lawn, was the epitome of Victorian propriety. So too was the interior. The drawing room was furnished with 'the usual complement of chintz-covered sofas and armchairs and a concert grand [as well as] occasional tables, china cabinets, escritoires, bureaux, pouffes, side-tables, ottomans and footstools'. In the dining room was displayed the gold casket containing Lancaster's Freedom of King's Lynn, bestowed on him along with a knighthood in recognition of his philanthropy towards his home town. William Lancaster had re-established his Norfolk roots by purchasing Eastwinch Hall, a modest late-Georgian country house a few miles from King's Lynn. His ambition to restore his family's wealth and prestige in the county had been achieved.

Osbert's maternal grandfather was also rich. Alfred Manger, whose surname derived from distant German ancestry, was one of a large family brought up in modest circumstances in South Kensington. His prospects were not particularly rosy, as Alfred's father, according to Osbert, 'although

Osbert after receiving his knighthood in 1975

in "trade", was not very prosperously so.' At the age of seventeen, he was dispatched to Hong Kong where an uncle found him a place in his shipping company. Over the course of the next fifteen years, Alfred succeeded his uncle as head of the shipping line and became one of the most prominent China Merchants or Tai-pan in Hong Kong, occupying Douglas Castle, a vast granite mansion in the Scottish baronial style on the Peak. By the age of thirty-two Alfred had made a large enough fortune to retire. He returned to England and bought a country house and estate near Gillingham in Dorset. Architecturally undistinguished, the house was recalled by Osbert as 'a medium-sized confusion of ivy, gables and white barge boards' which was filled with elaborately carved Anglo-Chinese furniture. The beautiful gardens betrayed his grandfather's true passion. They consisted of terraced lawns, winding gravel paths leading to rustic summer houses, fern-shaded waterfalls and clumps of rare coniferous trees affording a vista across the fields to the home farm.

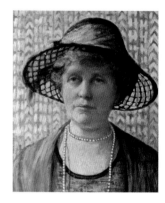

Self-portrait by Osbert's mother Clare

In Hong Kong Alfred had married 'a dashing widow' who bore him a daughter Clare, but due to the early death of her mother Clare was brought up not in Douglas Castle but by her maternal grandmother in Kensington. Alfred, having committed his daughter to her care, remarried and started another family back in Hong Kong.

Clare Manger, Osbert's mother, grew up to be an artistic young woman. She was sent to a finishing school in Brussels where she also studied in the studio of an established artist. It was in Brussels that the adolescent Clare first became aware of her psychic powers. This unproven conviction, along with a fascination for mystical religions, remained with her for the rest of her life. On her return to England, she became the last pupil of the Victorian artist G. F. Watts, before completing her training, around the turn of the century, in the artistic colony of St Ives. Clare was short, somewhat plump, with a wide mouth and, according to Osbert's description 'very beautiful pale blue eyes'. The arts, with the exception of music, were taken far less seriously by the Lancaster family. As Osbert observed, they 'were judged to be but enjoyable pastimes, more praiseworthy than bridge but less ennobling than riding.'

Osbert's father Robert, one of three boys and three girls, received a conventional public school education at Charterhouse before being sent to Berlin 'for a long residence and Leipzig where he attended the university'. The choice of Germany reflected the Lancasters' high-minded approach to life. They found in the Germans, Osbert explained, all those virtues which they most admired – discipline, industry, physical courage and simple, unaffected Evangelical piety. Religion also played an important part in Clare

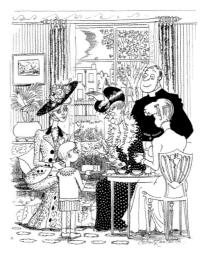

Osbert in his pram in Kensington (left) and at tea with his aunts (right). From *All Done from Memory*

Manger's upbringing. Her formidable grandmother, who was a pillar of St Paul's, Onslow Square, ran her household on strictly Evangelical lines.

Robert Lancaster and Clare Manger were married in St Paul's, Onslow Square. Their only child Osbert was born two years later on 4 August 1908. His birthplace was the family home at 79 Elgin Crescent, a respectable address in one of London's grandest Victorian developments, the Ladbroke estate in Notting Hill. The 'bright creamy' stuccoed house, with its pillared portico and classical mouldings, dated from the 1850s and consisted of three storeys and a basement; it perfectly suited the well-to-do circumstances of the young Lancasters. Robert earned his living in the City and the couple also received small allowances from their respective fathers. In total the Lancasters enjoyed a joint income of £600 a year, which supported an establishment of a cook, housemaid, nurse and a boot boy.

Osbert looked back on his pre-war childhood in Notting Hill as an idyll. Recalling those years in *All Done From Memory*, he summoned up a world peopled by Dickensian characters such as the crossing sweeper in Ladbroke Grove, the muffin man and the lamp lighter. He fondly evoked the leisurely pram rides to Kensington Gardens with Nurse, making their way through the press of horse-drawn traffic, 'butcher's vans with striped-aproned driver perched aloft [and] the painted donkey carts of the costers, who still wore their earrings and their high-waisted pearl decorated jackets'. There was plenty of kerb-side entertainment *en route*, such as a performing bear or the Italian organ grinders, 'all flashing teeth and curled moustaches', with their attendant monkeys. By the entrance to Kensington Gardens stood the familiar figure of the old lady selling balloons.

The cast of old ladies who made cameo appearances in the life of the young Osbert left an indelible mark upon his memory. The most ancient of all was his great aunt Martha, sister of Sir William, who had been born in the reign of George IV. She spoke with a marked Norfolk accent, was 'about as fragile as well-seasoned teak' and had eyebrows 'thick as doormats'. Her occasional visits to Elgin Crescent while staying with her brother in Putney

An Italian organ grinder and his monkey. From *All Done from Memory*

were announced by the stately clip clop of hooves as her carriage, drawn by a pair of greys, rounded the corner.

The Lancasters' next door neighbour, Mrs Ullathorne, hailed from an equally remote era. This archaic figure, her face coated with pearly white make-up, her cheeks rouged, her hair dressed in tight curls and fringes, had enjoyed considerable success at the court of Napoleon III. On display in her drawing room were innumerable *carte-de-visite* photographs dating from that period of 'crinolined beauties' and 'of dashing cuirassiers in peg-top trousers sporting waxed moustaches and elegant lip-beards'. Her singularity was enhanced in Osbert's eyes by her insistence that he should bow smartly from the waist and kiss her be-ringed hand when arriving on one his regular invitations to tea.

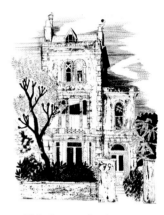

79 Elgin Crescent, Notting Hill, as Osbert found it in 1944, war damaged and derelict. From *All Done from Memory*

One day, Mrs Ullathorne presented him with her childhood scrapbook, a grand quarto volume bound in dark green leather, filled with hand-coloured engravings and fancy keepsakes. Osbert was instantly enchanted by this magic book and returned to it again and again. He was delighted with the images of over-plumed knights, 'their armour gleaming with applied tinsel', of 'shakoed' infantrymen assaulting an 'oriental' stronghold, and, on a quieter note, of little girls practising archery in chateau parks. These charming souvenirs of the romantic period provided the young Osbert with just the right pitch of visual excitement. They were in stark contrast to the other reading matter on the nursery shelves, collections of fairy tales along with classics such as *The Water Babies*, which had been childhood favourites of his mother. Their graphic illustrations, done by the virtuoso wood engravers employed by the famous Dalzeil brothers in the 1870s and early 80s, verged on the surreal in their obsession with three-dimensional realism. Osbert's reaction to them was fear, even revulsion. He recalled many years later, the 'devastating solidity' with which 'the more unpleasant creations of Hans Andersen's imagination' were delineated. Mrs Ullathorne's treasured volume, on the other hand, evoked the dashing French soldiers of King Louis Philippe or the knights of the Eglinton tournament through the liveliness of surface detail. It was an innocent, pre-Victorian world, of 'brilliant green lawns and flat improbable trees' which provided Osbert with 'a safe retreat' from that terrifying place 'of too completely realised fantasy'.

One other work claimed Osbert's attention. It was two bound volumes of *Picture Magazine*, dating from the turn of the century, which his father had subscribed to in his schooldays. Osbert loved the four-page photographic supplements dedicated to distinguished figures from different walks of life, and in particular the portraits of monarchs, 'some fish-eyed, some monocled, some vacant, some indignant' with their padded torsos

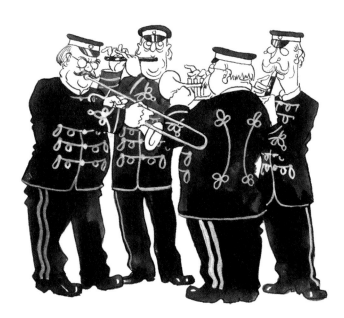

'Has anyone seen a German band, German band, German band?' From *All Done from Memory*

adorned with every variety of epaulette, plastron and aiguillette, hung with improbable crosses and stars, and laced with watered silk ribbons and tangles of gold cords. As soon as he learnt to read, the precocious boy even relished their unpronounceable names. For him, Mecklenberg-Schwerin, Bourbon-Parme, Saxe-Coburg-Gotha and their princely peers were imbued with high romance.

One of Osbert's most evocative vignettes of his childhood was associated with this colourful world of emperors and kings. It is early evening in the drawing room at 79 Elgin Crescent. The fire gleams and flickers behind the polished brass fender. His father sits at one side, having just come home from the City, reading a pastel-coloured evening paper; on the other sits his mother scrutinizing *Illustrated London News*. Between them, before the fire, lying on his stomach on the fur hearth-rug, is a small boy engrossed in an enormous volume 'perfectly happy counting the medals stretched across the manly chest of the hereditary Prince of Hohenzollern Sigmaringen'.

Both worlds were swept away by the World War declared on 4 August 1914, Osbert's sixth birthday. It was the time of his annual visit to Littlehampton on the Sussex coast, where he stayed with his parents in a boarding house kept by an old governess of his father's. The morning of the big day was spent on the beach with his father and it was then that Osbert realised something was amiss. His favourite entertainers, a brass band comprised of elderly gentlemen in tight-braided hussar uniforms, were nowhere to be found. His father on being quizzed merely whistled the refrain of a popular tune. The answer to the clue lay in the words which ran: 'Has anyone seen a *Ger*man band, *Ger*man band, *Ger*man band?'

In fact, the dismantling of Osbert's world had begun a short time earlier when his parents decided to move from Notting Hill to the village of Sheen, a Georgian enclave surrounded by Edwardian suburbia on the edge

of Richmond Park. The attraction for Robert Lancaster was the prospect of riding in the park every morning before breakfast. All the Lancasters of the older generation had a passion for outdoor exercise, which they also saw as character building for the young. Osbert found this hard to bear; he was 'never as a child a friend to violent exercise …' His mettle was frequently tested on visits to his grandfather in Putney where hard-hearted aunts, watchful of 'little Osbert's' tendency to 'softness', would chivvy him into the garden to join his cousins in a heavily organised game of rounders.

The long ascent up Putney Hill with keeper in tow always provoked a stream of complaints from the mutinous child. Only the treat of being with his father stiffened his resolve. Of those occasions, '… my father was with me and all was well, for not only did his conversation successfully dispel the boredom which this particular thoroughfare normally produced, but even had I felt tired I should in his company have made every effort to conceal the fact.'

Robert Lancaster, who had enlisted in the Norfolk Regiment at the outbreak of war, was killed in 1916 at the Battle of Arras. Osbert's reaction to his father's death was 'one of shattering disappointment rather than overwhelming grief'. He had been away for seemingly so long that although he had always remained a cherished and deeply missed figure, his image was fast becoming legendary. Osbert's bitterness was especially acute because the telegram arrived on the very day his father was due back on leave. Eagerly awaiting 'his jovial presence in the nursery' which Osbert knew would revitalise his own love for him, he was faced instead with weeping relatives in the drawing room. The ensuing weeks were filled with memorial services, crêpe arm-bands and black-edged writing paper.

As the conditions on the home-front deteriorated, depression settled over Osbert's life. It was induced by constant hunger and 'the appalling

Osbert playing croquet at East Winch Hall, his grandfather's house in Norfolk. From *All Done from Memory*

prevalence of mourning' which turned London into a metropolis of widows. His mother threw herself into working for the Red Cross, leaving him exclusively in the care of his nurse and the other domestic staff. An only child surrounded largely by women, he could hardly have been worse prepared for his next step in life, which was boarding school.

In September 1918, at the age of ten, Osbert was dispatched to St Ronan's preparatory school in Worthing, where for his first few terms he was continuously bullied and teased. His incompetence at games made him even more of an outcast, especially because the charismatic headmaster, Stanley Harris, who was worshipped by the boys, ranked as one of the greatest all-round players in the history of amateur sport, excelling at soccer, rugby and cricket. Gradually Osbert developed techniques for survival, not least on the rugby pitch where he cultivated a pose of studied detachment. His performance at one match was never forgotten by a boy from an opposing team. He recalled bearing down upon Osbert who, alone, stood between him and scoring a try. Osbert never wavered. "Do you wish", he asked insouciantly, "to pass me on the left or on the right?" By the end of his prep-school days, Osbert had achieved a measure of acceptance, even being made a prefect. He had also received an excellent education, thanks to a group of strong personalities on the staff who had drummed into him a basic understanding of the key subjects. 'I doubt very much', he observed, 'that my subsequent studies at Charterhouse and Oxford in fact added anything of importance to the conventional learning I acquired at St Ronan's.'

Prep school outing along the front at Worthing. From *With an Eye to the Future*

Osbert learning from 'Purple' Johnson, his art master at Charterhouse. From *With an Eye to the Future*

Osbert's father and uncles had all been at Charterhouse. Although an ancient foundation, the school was to all appearances Victorian, having been moved in 1872 from its original site adjoining the City of London to new premises, built in the Early English style, on a windswept spur of the Surrey Downs. When Osbert arrived in 1921 he was plunged into an atmosphere no less Victorian than the architecture. As an inmate of Pageites House, his life was governed by the imperatives of mastering an obscure argot and a legion of pointless rules. Transgressions were punished by beatings from the head of house with green 'whipping rods'. One law laid down that new boys were only permitted to converse with one another. This restriction even extended to asking the way from an older boy which, if ventured, was met at the very least with stony silence. At the time, Osbert felt a crushing sense of isolation. It also left him with a permanent inhibition so that, as he admitted over forty years later, 'I find it almost impossible to overcome my reluctance to address a word to anyone … to whom I have not been formally introduced.'

Compared to St Ronan's, the masters at Charterhouse made little lasting impression upon Osbert. One or two lingered in the mind but it was for their eccentricities rather than any ability to teach. His housemaster set no better example. A classical scholar who was getting on in years, he never knew the names of more than a handful of boys in his house at any one time and his contact with Osbert always remained distant.

For all its shortcomings, Charterhouse was redeemed in Osbert's eyes

by encouraging his nascent gifts as an artist. 'By great good fortune', he explained, 'there existed a long tradition of excellence in the graphic arts.' It could be traced back to William Makepeace Thackeray who as a Carthusian in the 1820s had infinitely preferred producing humorous drawings to studying the classics. His talent as a draughtsman was later obscured by his prowess as a novelist, although he did illustrate his collected works. Next in line was John Leech who, according to one contemporary, 'was the most popular boy in the school and the margins of his grammars were a delight to boyish eyes.' His reputation as one of the greatest social and political cartoonists of the nineteenth-century was made in the pages of *Punch*, where Thackeray was a fellow contributor. Generations of readers were also beguiled by his illustrations to Dickens's Christmas Stories and Surtees's sporting novels. The next to pick up the torch was Max Beerbohm, who arrived at the school in 1885. A precocious boy who hated games, he later recalled his times on the playing field when he would hover 'round the outskirts of a crowd tearing itself limb from limb for the sake of a leathern bladder', wishing instead 'for a nice warm room and a good game of hunt the slipper.' Even so, Beerbohm carved out his own niche in the school, largely thanks to his gift for caricature which was actively encouraged by the masters.

Beerbohm was destined to become one of the greatest literary and artistic figures of his generation and to exert the most potent influence over Osbert. He drew with great facility, turning out exquisite exaggerations of those in the political, cultural and social swim. Continually refining his technique, he experimented with a distinctive palette of subdued colours, with background detail and elaborate captions. Equally acclaimed as a writer, Beerbohm was originally branded an 1890s' decadent for his dandiacal contributions to the *Yellow Book*; he went on to establish himself as a respected drama critic and as a brilliant parodist. His Oxford novel, *Zuleika Dobson*, a tale of mass suicide, became a *succès d'estime*.

Charterhouse gave due recognition to her distinguished old boy in a way best guaranteed to promote the artistic lineage of the school. His published volumes of illustrations and caricatures were given pride of place where it mattered most, in the well-stocked library of the art studio, which was already rich in examples of the great illustrators. It was here that Osbert first became acquainted with the work of the dandy-aesthete.

Osbert, whose love of drawing had been nurtured by his mother, was a natural devotee of the studio, where boys with a serious enthusiasm for art were encouraged to spend their free time. The master in charge was 'Purple' Johnson, an old-fashioned watercolourist, so named, Osbert presumed, due

Max Beerbohm in later life

to his predilection for using 'a great deal of purple in the shadows'. Johnson, a regular exhibitor at the Royal Academy and the Royal Watercolour Society, believed, above all, in the importance of technique. Boys were drilled in academic drawing and given a grounding in the art – and craft – of watercolour. This regime included expeditions into the Surrey countryside during the summer term to paint *en plein air*. Once seated before some ancient lych-gate or ruined mill, his pupils were first required to sketch the scene lightly in pencil before covering the paper with an even wash of yellow ochre. Any boy who produced a sheet with patches or streaks was made to start again. Osbert recalled Purple Johnson's frequent admonition: 'Always remember, boy, to take a nice FULL brush.' Although his insistence seemed pedantic at the time, Osbert later acknowledged his debt to Johnson's rule: 'I owe to it a simple accomplishment which has proved unfailingly useful, and I remain eternally grateful.'

According to one of his closest friends, Robert Eddison, Osbert was by the end of his time at Charterhouse 'already an accomplished draughtsman'. He had also had a minor work of illustration, a decorative letter of the alphabet, published in the school's *Greyfriars Magazine*.

The school's enlightened attitude towards the arts extended to music. Osbert studied the flute to a high enough standard to perform in school concerts and at family soirées. He also received an excellent introduction to the classical repertoire through a programme of lectures and concerts, the latter performed for the school by the Guildford Symphony Orchestra.

Osbert had grown up into a good-looking adolescent, inheriting characteristics from both parents. He had large eyes, which were expressive and a brilliant blue like his mother's, a sensual mouth and a cleft in his chin. Like his mother, he was short. One physical drawback was acne, which was to leave his face scarred for life. All the Lancasters were naturally hirsute and Osbert had started to shave at prep school. Stanley Harris had warned him in his leaver's chat that at Charterhouse 'some totally degraded youth' might make 'certain disgusting suggestions' to him, which he must promise to reject. Although this cryptic advice baffled Osbert, it turned out to be unnecessary as no sexual advances were made towards him at Charterhouse, barring 'the occasional intrusion into my trouser pocket of a friendly but alien hand.' However, one of his first erotic experiences did occur at the school. It was the sight of a young woman 'becloched and incredibly short-skirted, displaying a generous quantity of pink silk thigh as she alighted from a low-slung Lancia.' The apparition was a young writer called Barbara Cartland who, at twenty-two, was already a published novelist and a journalist on the *Daily Express*. She was at Charterhouse to see her brother,

Ronnie, a year or two ahead of Osbert and a dazzling figure whose impact upon the school was akin to a 'supernatural phenomenon'.

The two first met properly in the summer of 1925 in the school bookshop, where Ronnie Cartland was enquiring about the arrival of Aldous Huxley's latest novel, *Those Barren Leaves*. A dandy with radical tendencies, Cartland dominated the school debating society, had launched two literary publications brightly titled *First and Last* and *Plus One*, as rivals to the pedestrian school magazine, and posed as an outrageous snob, forever complaining that Charterhouse was 'so distressingly middle class'. He was the embodiment of the *Zeitgeist* that was loosening the iron grip of tradition at the school. As Osbert observed: 'the breeze of change which had blown up with the 'twenties was just beginning, very gently, to eddy round the Victorian wind breaks of Charterhouse.'

Ronnie helped Osbert, now aged sixteen, to topple the barriers between school and the outside world. That same summer during the three-day exeat Osbert also suddenly became aware of the beauty and glamour of the London scene. He was loitering in Berkeley Square, as yet un-mutilated by brutal office blocks, surveying the comings and goings of smart Mayfair. A line of limousines, glittering in the sun, were drawn up outside Gunters, the fashionable tea shop; while, at the southern end of the square, 'bobbed and short-skirted girls' bearing expensive parcels sped up and down the steps in Lansdowne passage. The sight of an Hispano-Suiza parked outside an eighteenth-century doorway in Hill Street was invested with particular significance. This was the marque owned by Iris Storm, heroine of *The Green Hat,* the fashionable Mayfair novel by Michael Arlen which had been a set text for Ronnie Cartland and his circle. London was suddenly transfigured from the humdrum background of Osbert's home-life into a place of high romance. The sheen rubbed off on him; he was invested with a new-found

sophistication which greatly impressed his contemporaries. Robert Eddison, who shared a study with him at this time, acknowledged that Osbert tutored him in matters of taste. His reaction to Eddison's admiration for a particularly middlebrow play was uncompromising. Osbert, he recalled: 'informed me that *Rose Marie* had not been "the thing" to go to in the "hols" – *No, No Nanette* was the ticket.' One's choice of drink was another important question. Osbert, he added, 'bought me my first ever gin & tonic.'

The attractions of the adult world led to a restlessness in Osbert which coloured his remaining time at Charterhouse. In autumn 1925 he passed his School Certificate, a national examination, which secured his entry to Oxford. Rather than stay on for his last term, he managed to persuade his mother to let him leave school prematurely. This gave him the opportunity to spend the intervening months at Byam Shaw School of Art where he enrolled in the life class.

By giving in to Osbert's request, Clare Lancaster revealed the seriousness with which she took her son's artistic education. She herself had never lost her vocation as an artist; in fact it received fresh impetus with the ending of the war. Her first action had been to leave Sheen and return to the familiar territory of Bayswater where she purchased a modern house in the Georgian style in St Petersburg Place. At the same time, a determination to return to painting led to the renting of a studio. Her efforts at the easel were to meet with genteel success over the succeeding years with her well-painted but conventional flower pieces being regularly accepted by the Royal Academy. Although stylistically orthodox in her own work, her taste was catholic, embracing the more experimental movements of the day. Osbert had already been the beneficiary of her professional interest in the great masters of all periods as, from an early age, he had accompanied her

to private views at the Leicester Galleries and to the winter exhibitions of foreign schools at the Royal Academy. Indeed, it was Clare's desire to widen her son's knowledge of European painting and architecture that persuaded her in 1920 to overcome a nervousness of travelling abroad as a lone woman with a twelve-year-old boy and to visit France.

First they made a pilgrimage to Robert Lancaster's grave in the still battle-scarred plain around Arras. After that solemn task had been performed, they went on to Paris before embarking on a short motor-trip to the chateaux of the Loire. Ever since his delight in Mrs Ullathorne's scrap-book, Osbert had been a keen medievalist and he was enraptured by the feudal piles of Loches and Chinon. Equally he could not resist the fantastic silhouettes and romantic situations of castles such as Amboise and Azay-le-Rideau. For Osbert, the tour was a 'phenomenal success' and that, he acknowledged, was thanks entirely to his 'mother's inspired choice of itinerary'.

The expedition also inspired his enduring love of travel. The moment the Channel packet had berthed at Boulogne, Osbert was intoxicated by the strangeness of France: the waxed-moustaches of the gendarmes, the shutter hung façades, the glimpse from the train of 'a priest in soutane and shovel hat'. And then there was the smell that greeted him on the quay, which he later defined as 'a mixture of caporals, garlic, pastis, coffee and cheap Belgian coal.' For years, Osbert had longed to cross the Channel; a close study of A & C Black's *Peeps at Many Lands* led him to believe in the magical difference of 'Abroad'. France lived up to every expectation and he spent most of his time there in a state of euphoria.

Cultural trips abroad with his mother now became an annual event. Every Easter he also stayed with family friends at Roquebrune in the South of France. The Van den Eckhoudts were Belgians who had been offered asylum during the war by Osbert's grandfather in Putney. Mr 'Van den' turned out to be a painter who had studied in the same artist's studio in Brussels as Clare Lancaster, forging close ties between the two families. Not only did Osbert benefit linguistically *chez* Van den, although he always spoke French with a slight Belgian accent, but he also became well read in the French classics. Staying with the Van dens opened his eyes to the advanced culture of France. The works of Satie, Poulenc, Matisse and Stravinsky were common topics of conversation. He also met their friends who included Paul Valéry and the artists Simon Bussy and his wife, Dorothy.

Looking back after a life-time of travel, Osbert was to admit that the intensity of his youthful reaction to works of art had never been surpassed. He cited, in particular, his first visit to Venice when, on a solitary exploration before breakfast, he found himself in a long arcade hung with

canvas awnings. After a moment's hesitation, he pulled one of them aside to reveal the shimmering beauty of St Mark's Square. 'I could not have been less prepared,' he wrote, '… Slowly, in a state of exalted trance, I crossed the great Square at that hour empty of all but pigeons … I glanced right and saw for the first time the most staggering of all views, S. Giorgio Maggiore, floating above a dancing sea framed between the twin columns of the Piazzetta.'

Osbert described this vision as 'one of the two great moments of revelation of my childhood'. The other occurred in 1919 at the Alhambra theatre, again in the company of his mother who had taken him to see Diaghilev's production of *Sleeping Beauty*. Nothing had prepared him for the visual magnificence disclosed at the rise of the curtain. The dazzling beauty of the Bakst sets overwhelmed him, inducing 'the first great aesthetic experience' of his life. For weeks afterwards his drawing books were filled with attempts to recapture that glory.

His recollection of his ecstatic response to works of art contrasts with the bleak depiction of the visit to his father's grave in France. From the start Osbert's account belittles the physical impact of the vast cemeteries. 'In the long perspectives of identical headstones,' he wrote, 'stretching away across the uplands like some vast doll's housing estate, the individual message was successfully blanketed… .' This neutrality was reinforced by his mother's attitude; her journey to the graveside had clearly been undertaken out of duty and not 'to satisfy any deeply felt emotional need'. She believed that 'the moment the spirit had departed, the body had no further connection with the person one had known and loved.' Her way of explaining this to her son could not have been more prosaic. The body, she told him, possessed 'no more significance, dear, than a broken gas mantle.' Describing the event, over forty years later, Osbert still took his cue from his mother's detachment. He dismissed the sight of his father's grave as evoking '… in that neatly laid out valley of bones, hardly more emotion than an entry in the telephone directory'.

Osbert's defiant admission exposed an inner chill that was to afflict him all his life. It contributed to a pessimism which had first affected him, in quite a different context, during a conversation with his Lancaster grandfather, the bearded patriach whom Osbert had always treated with a combination of nervous awe and affectionate regard. On this occasion their talk had turned to the family crest, and his grandfather's refusal to take up a new grant of arms which would legally have allowed him to revive it. 'Complete, nonsense, of course,' his grandfather had insisted, 'and not worth the expense and trouble of following up.' Osbert did not

believe him. His grandfather had always had a fascination for his own family's heraldry and his tone of voice suggested regret at not having indulged this antiquarian passion. Indeed, he appeared to be on the brink of unburdening himself to his grandson; perhaps even to confess his lifelong sadness at having always suppressed his instinctive romanticism in favour of purely rational behaviour. Osbert admitted that this was, at least for him, an emotional moment. At last he would discover 'what exactly my grandfather was like beneath the protecting envelope of bearded bonhomie'. To his sadness and disappointment, no explanation was forthcoming. The psychological impact on Osbert was immediate. He was 'made suddenly and vividly aware of one of the central facts of human existence – the terrifying isolation of the individual and the resultant impossibility of ever really knowing another human being.'

William Lancaster was not the only member of the family to take cover behind a hirsute appearance. Osbert marked his departure from Charterhouse by growing, like his father, a moustache. 'It was compensation for something or other', he airily explained, 'but don't ask me what.'

UP TO OXFORD

In October 1926, Osbert went up to Lincoln College, Oxford, to read history. Lincoln was an obvious choice as the college enjoyed strong ties with Charterhouse. The Rector, Dean and several of the Fellows were old Carthusians, as were a number of prominent undergraduates who dominated the Junior Common Room and college societies. The sight of familiar faces, although reassuring on first arrival, soon palled.

Osbert saw himself as a man of the world, having spent the previous months at art school. Not only that, he also regarded himself as a veteran of the general strike, having helped out in Princess Marie Louise's canteen. Even so, he did not give up on college life straightaway. He dallied with the idea of joining the Boat Club in the hope that rowing might prove to be a sport at which he could at last excel. A few grim outings on the river soon brought him to his senses. The time had come to pursue an interest more suited to his gifts. Having acted at Charterhouse, he decided to join the Oxford University Dramatic Society (OUDS) which, as an added incentive, offered well-appointed club premises in George Street and a membership far more congenial than the hearties of the college boat club.

Osbert joined OUDS at a time when its reputation had never been higher. A policy, initiated in 1920, of hiring progressive directors from the professional theatre, many of them ex-members of OUDS who understood how to coax the most telling performances out of undergraduates, had

Osbert as Marat in an OUDS production of *The Fourteenth of July* without his moustache.

resulted in a string of successes. London critics now treated OUDS's first nights, especially their major Lent term productions in the New Theatre in George Street, with the same seriousness as they would a West End opening. Recent triumphs had included *Hamlet* and *Henry IV Part 2*, which the doyen of critics James Agate hailed in *The Sunday Times* as 'quite extraordinarily satisfying'. The play chosen for the next Lent term was the then rarely performed *King Lear*. Even more daring was the choice of guest director, the Russian émigré Theodor Komisarjevski, who was acknowledged as one of the greatest experimentalists of the international stage. His radical set design for the impending OUDS production lived up to every expectation. It was a towering structure, filling the entire stage and consisting of platforms and rostrums of varying heights, connected by narrow ladders. The undergraduate cast soon began referring to the set as the Mappin Terraces after the cliff-like enclosure for the polar bears at London Zoo.

King Lear provided Osbert with his first chance to tread the boards at Oxford. As befitted his untried status, he was originally given a non-speaking role as one of Goneril's drunken knights. However, with less than two weeks to go before curtain up, there was a cast reshuffle caused by the dropping out (at the insistence of his college) of the promising comic actor John Betjeman from the part of Fool. Osbert was consequently promoted to the Duke of Cornwall's servant, a small but eye-catching role, which centres on a fatal sword fight with the Duke, who abetted by Regan, dispatches him. The Duke was played by a dashing Old Etonian, Peter Fleming, another new recruit to OUDS, whose thespian credentials rested upon a love of amateur theatricals.

There was nothing amateur about Komisarjevski's rehearsals for the fight scene, which included training sessions with the university sabre champion. However, during the actual performances not everything ran

Osbert performing in OUDS production of *The Fourteenth of July* by Romain Rolland. The women of Paris are storming the Bastille with Osbert as Marat. From *With an Eye to the Future*

according to plan. Fleming's cavalier attitude to his helmet and gauntlets resulted in a couple of unprotected blows from Osbert, one inflicting a nasty wound which lent verisimilitude to the Duke's exit-line, 'I bleed apace.' On the last night, Osbert played the scene literally to the hilt when his steel blade snapped off and flew across the stage, narrowly missing Goneril. But nothing could detract from the staging of his death, which, thanks to Komisarjevski's set, became one of the highlights of the production. The fatal thrust occurred on the topmost ledge of the Mappin Terraces from which Osbert, heavily padded with concealed body-armour, tumbled. 'I confidently awaited', he recalled, 'the horrified intake of breath with which my dying fall … was regularly greeted.' The triumph of his *coup de théâtre* remained with him for years to come. In his memoirs, he recalled the 'highly important and spectacular scene' of which, he opined, 'I flatter myself, I made the most.'

Larger roles followed. He was cast as Sebastian in *The Tempest*, which was staged that summer in Worcester College gardens; he also appeared in the next Lent term's production at the New Theatre, Romain Rolland's *Fourteenth of July*, again directed by Komisarjevski. His part as Marat involved being assailed by a crowd of women storming the Bastille, in which he had to hoist a small child onto his shoulder and implore the *citoyennes* (fruitlessly) to 'listen to our little sparrow!' As a sign of Osbert's growing prominence in OUDS, he was largely responsible in March 1928 for the annual 'Smoker', held on a small stage erected in the Club dining room, which traditionally parodied the Lent term's play. He served as scriptwriter, contributing lyricist and choreographer, actor and director of *The Long Lived Libertines*, a musical comedy in three acts. His talents also extended to the design of the programme which included his own cover illustration of a prancing figure in the spirit of Aubrey Beardsley.

Osbert had first made his mark as a graphic artist at Oxford with his caricatures of the cast of *King Lear* published in the undergraduate magazine *ISIS*. They depicted leading lights of OUDS such as Peter Fleming, Harman Grizewood, who had played King Lear, and *ISIS* editor, John Fernald.

He soon became a regular contributor of caricatures, cartoons and humorous illustrations, usually signed with a distinctive cubist monogram. A series entitles 'Little Known Gems of Victorian Art' bore elaborate captions in the manner of Max Beerbohm, such as: 'The Prince Consort personally superintending the planning of the sanitary offices in the neo-gothic style for the sailors' home of rest at Portland Bill – School of Winterhalter.' Osbert's ironic drawings represented a late flowering of the Victorian Revival, a movement launched in Oxford some two years earlier by militant

'Peter Fleming doing his best to look ferocious as the Fiery Duke' in *King Lear*. (*ISIS,* 17 February 1927)

Little Known Gems of Victorian Art

No. I.

aesthetes, Robert Byron and Harold Acton, who had set out to mock Victorian taste. Undergraduate journalism was another of Osbert's great preoccupations at Oxford. He helped out first on *ISIS* and later on its less stuffy rival, *Cherwell*, where he served as sub-editor. This entailed 'sharing the direction' of the magazine with the editor, Maurice Green, and taking the rap for any defamatory articles. Their most difficult of many interviews with the proctors resulted in a heavy fine for publishing an indecent joke about the writer Godfrey Winn.

Osbert's artistic contribution to *Cherwell* was limited to the occasional full-page illustration which gave full rein to his passion for military uniforms, preferably Prussian, and the formal dress of diplomats and courtiers. Medals, ribbons and stars abound in his depiction of a diplomatic soirée, or his portraits of dashing cavalry officers. Often he left the face modishly blank except for a moustache and monocle. His childhood fascination with the portraits of heavily decorated sovereigns in *Picture Magazine* had never left him and he would still pounce with delight upon discovering fresh material. *Cherwell* reported in 'Sayings of the Week' his exclamation: 'There was an illustrated book of eighteenth-century uniforms – ooo – hold me tight!' Osbert, himself, could not resist donning a uniform for the OUDS Ball in June 1929 when he went as 'the gallant huzzar who fell dying before Napoleon at Ratisbon'.

By his third year, Osbert was well established as a caricaturist. An exhibition of his work, along with that of fellow sub-editor Angus Malcolm, was held during 1929 Eights Week in the club rooms of OUDS. The event was shamelessly promoted by *Cherwell* as 'one of the term's most amusing ventures [where] all the well-known Oxford characters will find themselves pilloried in a kindly spirit.' A second puff followed a week later which hailed the pair as 'clever workers with brush and pen' and anticipated 'a jolly afternoon' at the forthcoming private view. The publicity paid off. After

Little Known Gems of Victorian Art. 'The Prince Consort personally superintending the planning of sanitary offices in the neo-Gothic style – School of Winterhalter.' (*ISIS,* 19 October 1927)

enjoying 'prodigious sales', Osbert and Angus Malcolm considered investing the proceeds 'in a "twin" portrait by de László of themselves in Hungarian and Polish lancer uniforms respectively.'

Osbert was now a leading figure on the Oxford scene. A profile in *Cherwell* introduced him as 'magnificent and overpowering company' before going on to sketch an altogether more sophisticated portrait along the lines of one of Oscar Wilde's studied aesthetes. He is portrayed as a man who views any form of physical exertion as 'an error of taste', as one in whom even artistic accomplishment is subservient to a greater goal. 'Osbert', it is revealed, 'has never forgotten that art must be subordinated to the whole of life, that the essential Osbert must not be lost, even for instant, in the cartoonist.' The anonymous writer put his finger on Osbert's emergence as a character at Oxford. 'He has hitched his wagon to a star', the profile concluded, 'and alone of mortal men he has reached his star. He is what he wishes to be - Mr Osbert Lancaster.' His acting with OUDS, marked by a tendency to play to the gallery, had been harnassed to the greater role of playing himself.

Tom Driberg, a fellow *Cherwell* contributor, also left a vivid description of Osbert at this time. 'He looked a pixie Guardee', recalled Driberg, '… he was slight, but with sturdy shoulders; these he would raise mock-deprecatingly – lifting, too, his quizzical Max Beerbohm eyebrows – as if to compensate for his modest stature.' Driberg, who remained a life-long friend, compared this youthful performance to Osbert's vintage act of later years. At Oxford, he recalled, 'the persona had not acquired its full patination; the debonair condescension in which we now bask was often disguised as a courtly diffidence … If there was ever a real diffidence, the mask has become the face. There may well have been [as] his childhood … was punctuated by traumatic experiences.' His tone of voice echoed this undercurrent of melancholy. 'The voice', Driberg wrote, 'was always as it is now – an organ precisely designed to express, in sonorous but nonchalant cadences, a bewildered disdain at the follies of mankind.'

Osbert's striking physical similarity to Max Beerbohm was remarked by all his friends. John Bejeman said that he stood out from aesthetes and hearties alike: 'that round head, those round, observing blue eyes and that huge moustache, unique in a clean shaven age, looked like Max Beerbohm'. Osbert, like his hero, was a notable dandy, although his style was far removed from Max's nineties' elegance. He affected pinstripes, checks, pink shirts, wide ties and, occasionally, a monocle. Alan Pryce-Jones, another close friend at Oxford, described the effect as Edwardian.

Dandies and aesthetes were at the heart of Osbert's social circle. Many

John Betjeman while at Oxford.

congregated at OUDS where Osbert was often to be found ensconced on the 'high shabby-leathered fender' of the smoking room. They dined at 'the George', a bohemian café-cum-restaurant run by a Swiss hotelier who extended credit, or they drove out to the Spreadeagle Inn at Thame, ruled by John Fothergill, a survivor from the nineties.

'Would you mind telling me which is the gear lever?' Osbert behind the wheel.

His friends included the civilized plutocrat Harry D'Avigdor-Goldsmid, raconteur Denis Kincaid, literary tyros Alan Pryce-Jones and Graham Shepard, a Dada-ist in the person of Tom Driberg, the romantic swain James Lees-Milne, poets John Betjeman and Louis MacNeice, jazz musician Graham Eyres-Monsell, and maverick intellectual Christopher Hobhouse. Their chatter, antics and jokes were assiduously reported, usually by themselves, in the gossip column of *Cherwell*. Readers learnt that the dandy Bunny Roger, who favoured a green suit and yellow hair, had complained of a recent social event: 'It's not easy being the life and soul of this sort of party.' Peter Fleming's problems with acting, despite becoming President of OUDS, was another topic. His fears about playing Iago in *Othello* made it into print thanks to his admission: '… if I speak with a foreign accent in the play they'll just say "Oh Lord, there's Peter Fleming with a foreign accent"; if I don't, they'll just say "Oh Lord, there's Peter Fleming." ' Of numerous reported quips by Osbert, one exposed his airy incompetence behind the wheel. 'Would you mind', he was heard to enquire, 'telling me which is the gear lever?'

His friendships made at Oxford endured for life, but one of them – with John Betjeman – was in a class of its own. They had met early in Osbert's first term and almost immediately hit upon one of the many shared interests that were to engross them all their lives. This was the Victorians whom, at that stage, they affected to despise. Even John's father (born in 1872) was consulted. 'I cordially agree with you and Osbert', he replied, 'the Victorians were unpleasant as a rule, due no doubt to the fact that many quite well-to-do people were ignorant, vulgar and hypocritical.' Osbert's disdain was reflected in his illustrations, 'Little Known Gems of Victorian Art', for *ISIS*; John's surfaced in a critique in *Cherwell* of an ugly Victorian porch in North Oxford.

All the same, neither was blind to the architectural achievements of the Victorians. When John passed a Victorian church he was wont to exclaim: 'Phew! Gothic!' He acted as Osbert's bear leader on church crawls round Oxford which they often undertook with Maurice Bowra, a young don who served as mentor to the aesthetes. Christopher Sykes, another contemporary, recalled how 'Maurice Bowra and John Betjeman showed him the way down many intricate paths of exploration, even down into the terrible darkness

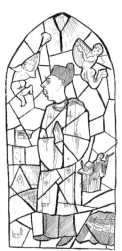

'This handsome window has been specially designed to the order of the Earl of Ava, Bishop Betjeman's life-long friend.' (*Cherwell*, 18 May 1929)

Going reluctantly to an unconventional church with his mother. From *With an Eye to the Future*

of North Oxford.' In his memoirs, Osbert acknowledged John's influence in opening his eyes to the stern beauty of churches by Butterfield and Street. He was, however, ripe for conversion. Osbert was, in his own words, 'period-besotted' and had already stored in his visual memory every detail of the crammed Victorian interiors of his childhood. It was a trait noted by Tom Driberg who pointed out: 'He must always have had a note-taking eye and a keen interest in the architectural setting of his life and art.' Oxford, under Betjeman's tolerant tutelage, had fanned the flame of Osbert's passion for architecture.

It was not just churches they had in common but also church going. Osbert was a committed Anglican who had been taking a keen interest in the rituals of church life since infancy. As a child he had relished the fashionable church parade after matins on a Sunday of St John's Notting Hill, where his father was churchwarden. It was heralded by the 'rustling murmur as the congregation rose from its knees gathering up prayer books and feather boas and adjusting veils and gloves.' Charterhouse, which had four chaplains, introduced him to the differing persuasions of the church. His recollection of the 'High' and 'Low' chaplains with their contrasting preaching styles never faded, whereas the masters at Charterhouse were all but forgotten. At Oxford, his tutor, Canon A.J.Carlyle, turned out to be of great clerical interest. He was said to be the last Christian Socialist, and had been the first to set up a soup kitchen in Vienna after the Armistice. Osbert described him as 'a man of great practical saintliness'.

Such ecclesiastical detail was manna to Betjeman. Having been an atheist at Marlborough, he had returned to the fold and was going through an ardently 'High' phase, worshipping at Pusey House, the centre of Anglo-Catholicism. His devotions were commemorated by Osbert in a mock design for a stained glass window, published in *Cherwell,* to commemorate 'Bishop Betjeman's' premature departure from the university. He is portrayed in the cassock, stole and beretta of a high churchman.

Acting, journalism and above all a similar sense of humour further united the pair. 'We liked the same jokes,' Osbert explained, 'we liked the same people.' One who fitted both criteria was Colonel Kolkhorst, a Reader to the University in Spanish and Portuguese, who held a salon every Sunday in his rooms in Beaumont Street. Attendance 'had become *de rigueur* for the smarter aesthetes'. His rooms were a shrine to the nineties: the shelves were lined with the *Yellow Book* and Wildeiana, pseudo-Beardsleys and Japanese prints adorned the walls. Over sherry or, if one was out of favour, marsala, the Colonel slipped well-prepared epigrams into his conversation. In pride of place on the mantelpiece was a photograph of Walter Pater, the high

priest of aestheticism. In his autobiographical poem *Summoned by Bells,* Betjeman recorded a subtle change to the image made by Osbert:

> *Upon whose margin Osbert Lancaster*
> *Wrote 'Alma Pater' in his sloping hand.*

It was the silver age of Oxford aesthetes. The heroic days of Harold Acton, Brian Howard, Robert Byron and their future chronicler Evelyn Waugh who, with cohorts of wits and exquisites, had routed the hearties in the cause of modern poetry, art and intellect, were past. However, their influence remained strong. The exodus had been prolonged with many going or being sent down in different years and others frequently returning for parties.

Continuity between generations was also provided by Maurice Bowra, classics don and Dean of Wadham, who had dispensed delicious food and drink as well as brilliant conversation to the first wave of aesthetes, and continued doing so to their successors. Osbert described him as 'by far the most influential of all the dons who took an interest in undergraduates beyond the purely pedagogic.'

Bowra had returned to Oxford as a scholar in 1919, having survived the carnage and the mud of the third battle of Ypres as well as being buried alive during the Battle of Cambrai. The horror of the trenches had left him with a 'hard-boiled' carapace – adopted as protection against the pain of events. Healing was slow. It had taken him three years as an undergraduate to realise that 'it was not always necessary to be on guard and that nothing was to be lost by giving myself away.'

Bowra threw off his own inhibitions and encouraged his undergraduate friends to do likewise. Osbert described him as 'an expert in the art of going too far, our most daring flights were never censured for being too outrageous.' Bowra's belief in what he called the 'big stuff' of literature – Homer, Pindar, Dante, Tolstoy, all read in the originals, raised the conversational stakes. And yet, an essential empathy lurking behind his bombastic delivery, defined by Anthony Powell as loud, stylised and ironic, inspired his guests. 'He had', wrote Osbert, 'the power to stimulate the brilliant response … with the Dean everything seemed speeded up, funnier and more easily explicable in personal terms. Abstract ideas, a passion for endless discussion [was] always firmly treated as extensions of personality.'

James Lees-Milne, who disliked Bowra, noticed his influence on Osbert. His manner of speech and technique as a raconteur, he recalled, made him 'too much the echoer of the horrid Maurice Bowra'. Osbert, however, defined Bowra's impact as 'life-enhancing'. He cited observing him

THIS WEEK IN THE GARDEN.

'Lilies. They toil not, neither do they spin; They're pure without – but not within.' Osbert's comment on dandy aesthetes. (*ISIS*, 8 June 1927)

Maurice Bowra dispensing champagne to his disciples.

swimming breast stroke in the Starnberger See, 'very high out of the water … reciting Rilke at the top of his voice'. 'Such experiences', Osbert said, 'were formative, demonstrating that opportunities for enjoyment were to be grasped wherever found, simultaneously if need be, and need not await categorization as intellectual, physical or aesthetic; that limits existed to be exceeded.' Here was a figure of authority in the University who, according to Powell, 'openly praised the worship of Pleasure … [and] the paramount claims of eating, drinking, sex… .' Powell concluded: 'Everything about him was up-to-date.'

Bowra's moral and intellectual standards liberated those admitted to his salon, who were, in any case, already ahead of their contemporaries in terms of creativity and sophistication. The force of his personality – an expression of the twenties *zeitgeist* – accelerated their development as artists, poets, novelists, critics, connoisseurs, academics and politicians. It was a moral code based upon self-interest, tempered by good manners. 'You don't get the best value out of your selfishness', he instructed, 'if you're selfish all the time.' As they made their way in life, many of his most successful adherents, Osbert included, were to cleave to this rule.

Culturally, Osbert was the ideal undergraduate to benefit from the breadth of Bowra's intellectual range. His French was excellent, having benefited from a thorough grounding at school and sojourns every Easter vacation with old family friends. During the long vacations, he embarked on journeys of cultural discovery to *Mittel Europa* inspired by the experimental writings of Sacheverell Sitwell, which had revolutionised attitudes towards the baroque. Having been taught German at Charterhouse, Osbert became at ease with the language on extended trips through Germany, Austria and Hungary, 'sharing to the full the contemporary passion for the baroque'. A dutiful pupil, Osbert confirmed that '… few were the masterpieces of Lukas von Hildebrandt and the Asam brothers with which I was unacquainted… '

If only such thoroughness had been applied to his academic studies. Having gone up to read history, he had changed to English in his second year with disastrous consequences. Medieval literature and minor Elizabethan writers left him cold. Anglo-Saxon proved 'insufferable'. Half way through his third year, it became clear that he was riding for a fall. It was decided he should stay on for a fourth year to ensure a pass. He retired from *Cherwell*, made his farewell appearance on the stage, gave up his rooms in fashionable Beaumont Street and withdrew to lodgings, far from temptation, off the Iffley Road.

This high-minded plan was derailed almost immediately by a new distraction. The Ruskin School of Art, which had been moribund for years,

suddenly sprang back into life in 1930 under the inspired leadership of Albert Rutherston. The life class proved irresistible to Osbert. Originally he rationed himself to one day a week, but soon he was spending all hours in the studio, soaking up 'the old familiar smell of turps'. His teaching draughtsman was Barnett Freedman, described by Osbert as 'first rate'. A brilliant commercial artist, Freedman made a lasting impression on Osbert, who judged that with the exception of McKnight Kauffer 'no man in this country did more to restore the standards of commercial art.' Osbert, who was to develop an impressive commercial practice himself, also acknowledged Freedman's achievement, through tirelessly harrying publishers and advertisers, at establishing a decent rate of pay for artists.

As his finals loomed, panic set in. His worst moment was having to translate a passage of Anglo-Saxon unseen in his Viva for a particularly aggressive female don. The only intelligible words on the page were Jesus Christ, which he brightly translated before falling silent at the rest of the text, leaving his examiner with the unfortunate impression that he had uttered an expletive. To his amazement, Osbert was awarded a fourth.

AFTER OXFORD

Osbert came down from Oxford in the summer of 1930 with no definite plan as to what to do next. Ideas of pursuing a career as an illustrator met with little enthusiasm from his mother. She believed, like many rich people, that she was as poor as a church mouse, but there was another reason for her equivocation. Unbeknown to Osbert, she had cast his horoscope at birth which had predicted a glittering career in the law. Osbert was sent off for a 'serious talk' with the head of the family, his uncle Jack Lancaster who, for different reasons, took a dim view of his aspirations. This had nothing to do with economic necessity. 'Psychologically', Osbert explained, 'there was tremendous pressure from the family that unearned income was a disgrace. It was an almost pathological thing to get the earned money ahead of the unearned income.' The Lancasters believed in work for work's sake, and that by definition, meant regular, long hours in an office. Art was considered an enjoyable pastime but never a profession. 'It's all very well drawing funny pictures,' lectured uncle Jack, 'but it don't get you anywhere.'

To illustrate his point, his uncle cited the fate of a contemporary from his schooldays: 'there was an awfully clever chap in my form at Charterhouse', he told him, 'who did wonderful caricatures of all the masters. We all thought he had a great future but I've never heard of him since. Can't remember his name but he was a half-brother to that actor fellow Tree.' Although Osbert came to know Max Beerbohm well in

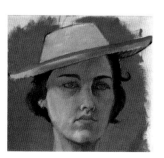

Osbert's portrait of Karen at the time of their marriage.

later life, he 'never quite found the right moment' to entertain him with this anecdote.

Osbert dutifully enrolled at a crammer in Chancery Lane to read for the Bar. Nor surprisingly, he soon discovered that the subject was even less comprehensible than Anglo-Saxon. Testimony was provided by his exam results: he failed Roman Law once, Common Law twice and took one look at the Real Property paper and walked out to see a Marx brothers film. Mind and body were in open revolt. A few days later, he was seized with a violent coughing fit which led to haemorrhaging. The spectre of tuberculosis induced utter panic which owed nothing to his admitted 'unlimited capacity for self-dramatisation'. The X-rays were inconclusive but it was deemed essential to retire to a sanatorium in Switzerland for observation. After three months of tests, rest, light exercise and delicious food, Osbert was given a clean bill of health. On his return to London in the spring of 1931, he had no difficulty in convincing his mother of the fatal consequences of working in an ill-ventilated lawyer's office. Playing on her artistic instincts, which in the past had always led her to support his ambitions, he pressed the case for attending the Slade School of Art. Permission was readily granted.

Teaching at the Slade followed well-hallowed precepts first laid down by the formidable Professor Tonks who had dominated the school until the mid-twenties. Students were encouraged to use their brush like a pencil to draw directly onto the canvas, rather than to achieve 'painterly' effects. In similar vein, colour was strictly controlled in the pursuit of 'tonal values'. Osbert worked away in the approved manner, producing sombre still lives and understated landscapes which were exhibited at the highly respected New English Art Club. At the same time, he usefully followed up his interest in the theatre by attending the course on stage design taught by Vladimir Polunin, a Russian exile who had been the principle scene painter for Diaghilev. His many credits included working with Picasso on *The Three-cornered Hat*. Under him, Osbert learnt the craft of set painting which, as it turned out, was to stand him in good stead in his later career. There was a more immediate cause to be grateful to Polunin. He introduced him to another of his students, Karen Harris, a sultry beauty who, two years later after a long and frustrating courtship, became his wife.

Osbert had always had a keen eye for women, although his rarefied life at Oxford had offered few opportunities to mix with the opposite sex. Undergraduettes, as they were known, were looked down on by Osbert's circle. 'Their entertainment', he pointed out, 'which took the form of morning coffee at the Super was left by right-thinking men to the scruffier members of the dimmer colleges.' The female students at the Ruskin School

of Art were far more to his taste. He found 'those long-bobbed, charcoal smeared girls in ostentatiously dirty overalls' another compelling reason for cutting English lectures in favour of the life class.

Osbert was too shy to take things further. He was also too well aware of his mother's stern views regarding pre-marital sex. Even by the standards of her generation, Clare Lancaster was a represser. She found the subject of sex, according to Osbert, 'not so much distasteful as virtually incomprehensible'. The sublimation of her own longings, he speculated, could have contributed to the awakening of her putative psychic powers in adolescence. Clare, meanwhile, had kept an eagle eye on her son's morals to such an extent that he recalled in old age: 'I was as innocent as a child practically when I married.'

Karen Harris sprang from a clever, eccentric and talented family. Her father, Sir Austin Harris, brother of the celebrated *Times* correspondent in Tangier, was a cultivated banker who collected art. Tall, handsome and aloof, he was also lachrymose, prone to bursting into tears at the sight of the household accounts. His concern over money had little to do with personal circumstances as, despite the 1931 crash, he remained extremely well off, with a large house in Westminster, copiously staffed. Karen's mother Cara was an amateur artist who, under the *nom de brosse* Rognon de la Fleche, painted still lives, classified by John Piper as 'little roses, very delicate chi chi things.' He pronounced them terrible.

In terms of provenance and style, Cara Harris was the product of Osbert's favourite period. Her mother, Mabel Batten, a great beauty, had been the lover of Edward VII, when Prince of Wales, and of Radclyffe Hall, author of the lesbian novel, *The Well of Loneliness*. Cara, herself, according to Osbert's affectionate account, was a woman of 'quite remarkable, although totally unfashionable, beauty', whose appearance gave the impression of 'having slipped into something loose on coming back from George V's Coronation'. Everything about her, to his delight, was 'unshakeably pre-war'.

The Harrises were highly protective of their youngest child, Karen. At the age of eleven, she had been diagnosed with diabetes, becoming one of the first to be treated with insulin. As a result she had never been sent to school nor, according to her daughter Cara Lancaster, 'ever been made to do anything she didn't want to do.' A year was spent in Munich learning German, otherwise her only occupation had been to take up dressmaking. Her facility with needle and thread revealed a natural brilliance with her hands. Ideally qualified for Polunin's course, she went on to excel in all the necessary skills, including carpentry and electrics, for the construction of props, models and sets.

Following Osbert and Karen's first meeting at the Slade, a year passed

Canon Carlyle, Osbert's old tutor from Oxford, who took Osbert and Karen's marriage service. From *With an Eye to the Future*

before her parents would even consider his suit. He was eventually invited in the summer of 1932 to stay with them on the Isle of Wight for a probationary visit. John Betjeman, who for a time had been in love with Karen's cousin Camilla Russell, accompanied him. 'Smoglands', a nondescript pebbledash villa, located on the outskirts of Bembridge, had been bought on a whim, some years earlier, by Cara Harris against her family's advice; they argued that it was too small for someone of her expansive personality. She had soon seen to that by putting in hand an almost continuous programme of improvements. Over the years bow windows had bulged out, a guest wing been added and staff quarters thrown up on the site of a shrubbery. Gypsy caravans, to be used as overflow accommodation for weekend guests, were dotted around an adjacent field. Not to be outdone, her husband built his own summer residence, along with gazebos and a walled garden, on neighbouring ground, designed, according to Osbert, 'in the then fashionable pseudo-Spanish style'.

In the future, the architectural eccentricities of the Harris's were to prove a source of great enjoyment to their son-in-law. In the meantime, it was made clear that the couple would have to bide their time before getting engaged. Karen, who was five years younger than Osbert, was not quite eighteen. Their engagement was finally announced the following spring when the couple were permitted to take a skiing holiday together, suitably chaperoned, at Garmisch in Switzerland. They were married in June 1933 by Osbert's old tutor from Oxford, Canon Carlyle, at St Peter's, Eaton Square. The honeymoon was spent in Venice. Before the event, Clare Lancaster gave her future daughter-in-law some words of advice. 'Now dear,' she confided, 'don't let Osbert be tiresome. I know what those Lancasters are like when given half a chance and I was always very firm with his dear father.'

Karen was a perfect match for Osbert, as many of his close friends observed. John Piper who met her in 1940 summed up her attraction: 'she was a marvellous woman, very sensitive and intelligent and really creative, terribly kind, frightfully funny.' Karen's mother proved a good butt for her humour. Obsessed with hygiene, Cara Harris always travelled abroad not just with her own sheets but also her bidet, an elaborate Victorian model, decorated with hand-painted floral sprigs. Once Osbert, much to his embarrassment, had to carry this receptacle the length of the Blue Train after it had been mislaid on the Calais quayside. Karen attempted to ease the situation by explaining: 'You must realise, darling, that my poor dear mother suffers from a bidet-fixe.' John Betjeman loved her jokes. His affection for her resonated in his pronunciation of her name as Kar-een;

he thought it sounded like a car lubricant.

Osbert and Karen started married life in a top floor flat with a studio in a mansion block at 2 Melbury Road, part of a 'solid enclave of late Victorian culture' on the edge of Holland Park. Osbert pursued his career as a freelance writer, journalist, illustrator and artist, his chosen course since leaving the Slade the previous year. He continued to exhibit at the New English Art Club and also turned his hand to numerous small commissions, such as designing Christmas cards for the likes of laundries, and posters for church bazaars. Later work included pamphlets for Shell and poster for the London Passenger Board publicising matches at Lord's and Trooping the Colour.

A change in his situation, which brought about a more regular flow of work, occurred in 1934 when he accepted a freelance editorial post on *The*

Lord's 1935 Test Match poster for the London Passenger Board.

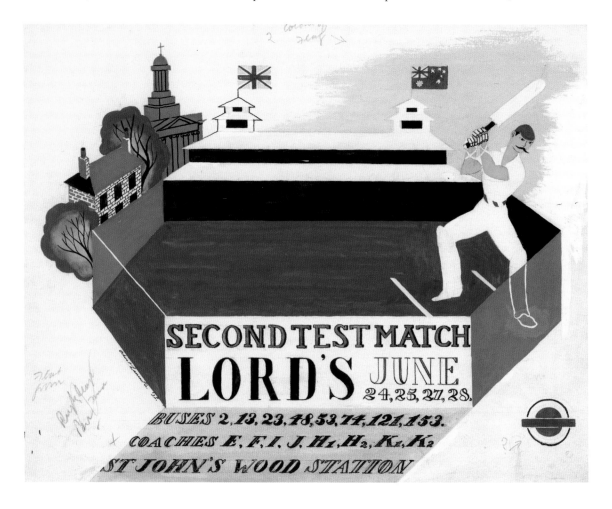

Architectural Review. Friends in high places had secured the appointment. Osbert had known the editor, Hubert de Cronin Hastings, since childhood thanks to a long-standing friendship between their mothers. John Betjeman, the assistant editor, also had a hand in the decision.

Under de Cronin's direction, *The Architectural Review* had become the mouthpiece for the fledgling modernist movement. Not content with employing a team of forward-thinking journalists such as J.M.Richards and F.R.S.Yorke, he designed glamorous layouts printed on expensive rag paper to proclaim each new architectural landmark as it appeared in Europe or America. A counter-balance to the modernist tendency was provided by John Betjeman, who inhabited an office deliberately decorated with William Morris paper, and Robert Byron, who wrote magisterial surveys on Lutyens' New Delhi and on Russian architecture. Although Osbert was by no means anti-modernist, his natural sympathies and interests aligned him with the Betjeman-Byron camp.

Osbert was taken on to write diary pieces, captions, book reviews and features. The longer articles often combined social with art history, 'The English at the Seaside' for instance (July 1936), or 'The English way with Ceremonial' (April 1937) which was published to coincide with the 1937 Coronation. All display a suitably light touch. His article 'Royal Patronage' (June 1935) includes a paeon of praise to the 'agreeable Prince', later George IV, for his life-long devotion to architecture. 'The sound of the chisel and the hammer', Osbert writes, 'and the dull thud of arriving bills were the continuous accompaniment to life at his numerous palaces.'

'Royal Patronage', an impressive *tour d'horizon,* which encompasses castles, palaces and exotic pavilions across Europe, reveals his cosmopolitanism, the fruit of leisurely cultural tours of summers past. His love of minor German courts encouraged entertaining asides. He briefly dwells upon 'the unusually spacious dining halls in the palaces erected by the Princes of Hesse-Cassel and Hesse-Darmstadt, which were due to a family weakness for drilling large bodies of troops indoors on wet afternoons.'

When need be, Osbert summons considerable scholarship to support his case. His review of *German Baroque Sculpture* (September 1938), a collaborative effort by Sacheverell Sitwell and Nikolaus Pevsner, cites important omissions and makes unfavourable comparison to Pinder's *Deursche Barockplastik* which he adds, helpfully, is cheaper. When in command of the subject, he is capable of writing with a bravura that evokes great sweeps of art history. Of German baroque sculpture he states: 'one readily detects the presence of that strange tenseness, that curiously exaggerated realism which … one might justifiably refer to as super-realism which

is visible in so much German medieval sculpture and is overwhelmingly present in the paintings of Grünewald, [and] is the backbone of the movement known as expressionism.'

The Architectural Review first published Osbert's art criticism, which was to remain a mainstay of his journalism. His taste was already assured, singling out contemporary artists as diverse as Edward Burra, Gilbert Spencer (one his tutors at the Ruskin), Giorgio de Chirico, Glyn Philpot, John Armstrong, Edward Wadsworth and Paul Nash. This authority, which has stood the test of time, was rooted in his own work as an artist. 'Some practical personal experience', he wrote of the role of the critic, 'of what happens between the vision in the artist's mind and its transference to paper or canvas or wall, is of so inestimable help that I am tempted to consider it essential.'

His most lasting contribution to the magazine was an illustrated architectural satire published in monthly instalments entitled 'A Short History of Pelvis Bay'. Written as excerpts from a municipal guidebook, the series formed the basis of a book *Progress at Pelvis Bay* which was published in 1936 by John Murray.

The spoof guide opens with a short history of the town's progress from humble fishing village to Regency resort to Victorian seaside town, transformed by the railways, and finally to the expanding municipal borough of the present day, easily reached via a smart new by-pass by luxury coach or car. A sequence of drawings delineate the march of architectural progress marking the disappearance, in turn, of the original weather-boarded houses, the regency rows and the Victorian esplanade, until one reaches the Winter Garden erected circa 1930 in a 'modified Renaissance style'. Illustrated sections follow which detail parallel changes to individual buildings and monuments.

The anonymous author of the guide, an eager apologist for the District Council, hails each new development encountered on the tour: the

Jacket artwork for *Pillar to Post* (1938).

demolition of those monotonous Georgian and Regency terraces to make way for a palatial cinema or, in the case of the 'inconvenient' Assembly Rooms, a vast new bathing-pool; the replacement of an old shop front with a cheery new version of plate glass, chrome and neon lights; the spread of modern houses over the downs 'especially designed to harmonize with the beautiful landscape'.

En route, it becomes apparent that the District Council abides by certain important principles. Any building which harks back to 'some quaint half-timbered old place' is welcomed at Pelvis Bay. Local talent is also always being encouraged. Plans drawn up in 1930 by a continental architect for a Country Club are considered 'too daring in conception' by the District Council who have a local man water them down 'with the happiest results'. Tinkering with a public building is acceptable, but imposing restrictions on private housing is quite another matter. 'The authorities at Pelvis Bay', our guide insists, 'have never had any sympathy with town-planning … preferring rather to leave things to the natural good taste of the individual.' The rewards, he points out, are plain to see on the hitherto virgin downland where the freedom to build in a variety of styles reflects the council's 'praiseworthy anxiety' to preserve rustic beauty.

Osbert's deadpan delivery, supported by illustrations crammed with telling detail, skewers the spokesman for the District Council. His irony exposes the greed, philistinism, parochialism and antiquarianism which characterized the mutilation, both actual and threatened, under way in cities and towns across England. This was Osbert's first shot, and one his most deadly, in his long career as a conservationist and architectural campaigner

Progress at Pelvis Bay was widely and well reviewed. Peter Quennell described it as 'a book that should find an honoured resting place in the library of every architectural college, training school and public institution.' Osbert's next salvo on the subject of architecture, *Pillar to Post,* was published in 1938. It was a disarming picture-book with a reforming agenda: to address 'the present lamentable state of English architecture' caused by the passivity of the intelligent public who 'when confronted with architecture, whether good, bad or indifferent, remain resolutely dumb – in both the original and transatlantic senses of the word.' Victorian theorists such as Ruskin were to blame for this state of affairs. They confounded architecture with morals and religion, removing it from the realm of ordinary mortals. Architecture had become an abstruse subject which the discerning individual 'could never hope properly to understand and possessed of a scale of values that he must take on trust.' Osbert's aim was to encourage a less reverential attitude and to inspire people to open

A spoof municipal guidebook to the town of Pelvis Bay (1936).

Wimbledon Transitional: 'Its plentiful use of pebbledash, its giddy treatment of gables and its general air of self-conscious cosiness is plainly revealed as an unattractive offspring of Art Nouveau.' From *Pillar to Post*

their eyes to the buildings around them. Only by fostering a new climate of critical opinion would 'worthier' architecture result.

Osbert made light of his means of overturning a century of dogmatism and ignorance. His 'slight volume', he argued, was merely a picture-book 'leavened by a large dose of personal prejudice.' His scope, however, was vast. *Pillar to Post* is an illustrated survey of British architecture from Stonehenge to twentieth-century functionalism, consisting of a pithy summary of each style with an accompanying illustration. The remoter periods follow the familiar genealogy of established styles from Norman, Early English (Stonehenge is categorized as Very Early English), 'dec' and 'perp'', through Tudor to Queen Anne, concluding with the Regency. The next 140 years, which cover half the book, are divided into far more numerous classifications, most invented by Osbert. The nineteenth-century includes Municipal Gothic, Kensington Italianate, of which his birthplace Elgin Crescent was a minor example, and one of his most famous discoveries, Pont Street Dutch, a style first mentioned by him three years earlier in *The Architectural Review*. A cluster of important new identifications shed light on the first four decades of the twentieth-century. Wimbledon Transitional, Stockbrokers' Tudor, Bankers' Georgian, By-Pass Variegated, and Pseudish are all carefully drawn and described.

Key architectural movements, which have a bearing on English taste, are included, namely Greek, Roman, Renaissance and Baroque. Their presence betrays the self-confessed 'prejudice' of Osbert's approach. In his eyes, the peak of perfection was Greek Doric, 'the subtlest, the most complete and the most purely logical style of architecture that the world has ever known'. Medieval Gothic, by comparison, had its moments of greatness but, as a style, was terminated by the revival of classicism at the Renaissance. This he describes as 'a highly welcome development'. So vital was its creative

Decorated (detail): 'The needs of common humanity must be counted'. Architecture must 'be appreciated in relation to daily life'. From *Pillar to Post*

force, especially when flowing through the baroque, that for the next four hundred years, classicism reigned supreme. England, although a late starter, enjoyed 'a truly splendid flowering', neatly summarized by Osbert as 'Palladian, Wren, Palladian again, Greek Revival', which produced masterpieces of European significance.

Osbert's analysis was modelled on the critical theory of the writer and poet Geoffrey Scott who, in *The Architecture of Humanism,* a book much admired by Oxonian aesthetes, had defended and celebrated the Renaissance aesthetic in architecture. Central to Scott's thesis was the belief that great architecture was the product of taste, by which he meant a preference for the formal qualities of design. In Scott's view, this long 'reign of Taste' was brought to an end by the romantic movement and its offspring the Gothic Revival. Likewise, Osbert argued that out of the 'charming chrysalis' of Gothick 'would one day come the blundering dreary great moth of Victorian revivalism.'

Gothic revivalism and its pontiff, John Ruskin, were anathema to Osbert. Thanks to him, he wrote: 'The gothic was now regarded as not merely the most beautiful method of building but also the most true.' Buildings had to be a 'slavish resuscitation' of a long-lost method of construction and not, as in the case of the renaissance, a movement 'constantly discovering new forms of expression while still employing the same classical idiom.' Osbert had no truck with 'truth' in architecture. The Georgians, he argued, had revived styles which required respect for historical precedent but still produced masterpieces 'which just goes to show that in architecture, it is the architect, not the formula, which counts.'

The needs of common humanity also counted. For Osbert the test of a good building was enshrined in Geoffrey Scott's maxim, prominently quoted on a preliminary page: 'The art of architecture studies not structure in itself, but the effect of structure on the human spirit.' Osbert considered that architecture's 'full significance is only to be appreciated in relation to the daily life, the aspirations and the ideals of those it was created to shelter or amuse.' His illustrations, drawn with such assurance and wit, and which always include amusing figures coming and going, were his masterly expression of this belief.

Osbert blamed the Gothic Revival for spreading the plague of revivalism that had, ever since, beset English architecture. His loathing inspired some of his greatest flights of architectural satire as he dissected with an acute eye for telling detail and phrase, each revival in turn. He notes that Scottish Baronial, although predominately a domestic style,

'was also extensively employed for prisons.' Pont Street Dutch, he remarks, is so prevalent in Hans Place and Cadogan Gardens that 'the wayfarer in that high-class residential district might easily imagine himself to be in Vermeer's Delft'. On a more scholarly note, Wimbledon Transitional is identified as the 'unattractive offspring' of a liaison between Art Nouveau and Pont Street Dutch. The latter's parentage is revealed by a shared 'fiendish variety of surface materials' which includes pebbledash, ridge-tiling, fancy brickwork, weather-boarding and half-timbering. Stockbrokers' Tudor, a poor relation of Wimbledon Transitional, he points out, has stimulated the mass-production of 'old oak beams, leaded window panes and small discs of bottle glass' which 'our ancestors lost no time in abandoning as soon as an increase in wealth and knowledge enabled them to do so.' Osbert could not forgive the Tudors for inspiring the rash of 'olde Tudor tea-shoppes and Jacobethan filling stations' across the land – and dismissed their architecture as having little to recommend it.

Jacket artwork for *Homes Sweet Homes* (1939)

Only once does Osbert's wit desert him, revealing the depth of his anger at the current plight of British architecture. The last revival in his inventory was Modernistic (now generally included in the term Art Deco), as applied to the façades of luxury cinemas onto which, he stated, every 'tuppeny-ha'penny builder' has no compunction in slapping meaningless ornamentation. 'These bars of beaten copper, these sheets of black glass, these friezes of chromium pomegranates, not only did not arise out of the demands of construction but had not the slightest shred of tradition to provide a threadbare excuse for their revolting existence'.

Part of Osbert's hatred of the Modernistic style was due to its debasing of the principles of the altogether different Modern Movement, which were then, thanks significantly to *The Architectural Review*, gaining currency in England. Osbert concludes *Pillar to Post* with his version, termed Twentieth-Century Functional, a style, he explained, 'of the utmost austerity, relying for effect on planning and proportion alone.' The impact on the design of utilitarian buildings was admirable. However, he questioned its appropriateness for domestic architecture, arguing perceptively that a style founded on Corbusier's concept that a house was '*une machine á habiter*' 'presupposes a barrenness of spirit… we have not quite attained.' However, he applauded modernism for having 'a revivifying effect', regarding it as a style not yet fully developed, which offered considerable hope for the future.

Osbert's humanist approach, reflected in his sceptical response to Corbusier's diktat, came to the fore in a companion volume to *Pillar to Post*, published in 1939. *Homes Sweet Homes* illustrates the interiors of the buildings described in the previous volume. Preferring Bouffon to Corbusier, he

Even More Functional: 'When Monsieur Corbusier first propounded his theory of the house as *une maison á habiter* it may be doubted that he foresaw the exact form in which it would be translated into fact.' From *Homes Sweet Homes*

quoted in the preface his aphorism: '*Le style c'est l'homme même*'.

Like a bug hunter in search of new species, Osbert bags some previously unrecorded specimens, notably Le Style Rothschild, Vogue Regency and Curzon Street Baroque. Indeed, one of the last examples in the book, Even More Functional, had only just been invented. It was inspired not by Corbusier but by that other well-known architectural authority Herr Hitler. The interior is an air raid warden's post, described by Osbert as an exercise in 'rugged décor', which had yet to reveal its long-term influence on the history of interior decoration.

The book came out in November 1939, just two months after war had been declared. Even so, it reprinted immediately and again, despite paper shortages, in 1941 and 1944. *Pillar to Post* had proved equally popular and had been well received by the critics, particularly in the architectural press. The advocate of modernism, J.M.Richards, had hailed the book as one 'that should be read by Mayors, Councillors and Committee-men (and, indeed, architects) everywhere.'

Osbert had written one other book before the war. It was a work of popular history, published in 1936, entitled *Our Sovereigns* and consisted of biographical sketches of every monarch since Alfred the Great together with portraits reproduced from a 'Monarchy Chart' originally published by Eno's Fruit Salts. The project had been dreamt up by Osbert's publisher, Jock Murray, to capitalise on the coronation of Edward VIII. His opportunism was rewarded with having to rush out a revised edition following the abdication.

Jock Murray had first become Osbert's publisher through the introduction of John Betjeman, who had suggested turning the original articles on Pelvis Bay into a book. He was to remain his publisher – and the closest of friends – for the rest of Osbert's life. Over the years, the elegant Murray office at 50 Albemarle Street, occupied by the family since 1812,

Osbert with his publisher and friend, Jock Murray, at 50 Albemarle Street, London, in the '50s.

became a second home to him. Indeed, the Murrays had only stopped living in the building in 1929 when it became the publishing office (although still treated by Jock as his home) and retained the custom of offering afternoon tea to passing authors and friends in the gilt-papered drawing room hung with portraits of Lord Byron and other famous Murray authors. When working on his architectural satires, Osbert would drop in almost daily with a new spread. 'If he agreed to do a book it would come at a rate of knots', recalled Jock Murray.

Osbert was to become one of the stars of the Murray list, not least thanks to Jock's idea, at the height of the war, to publish collections of his cartoons. They were an instant success.

Jock knew how to handle Osbert. He would encourage him with well aimed praise but could also be tough. 'If he lost impetus,' Jock pointed out, 'wild horses, money, entreaties, nothing would get [a book] out of him.' Occasionally, his son John was required to bar the front door to prevent Osbert's escape until the required text or drawing had been completed. Frequently, around the cocktail hour, Osbert would drop in on Jock, who had a ready supply of his favourite Turkish cigarettes to hand. He would then entertain him with a stream of outrageous gossip.

'The book was only part of my father's relationship with his authors,' John Murray observes. 'He was their *confident*. They trusted him.' None more so than Osbert, the most private of men, who later was to confide in Jock at times of emotional turmoil.

The closeness of the two men, who were near contemporaries, extended to their respective wives and children – contributing to the air of contentment felt by Osbert in the early years of his career.

Looking back over the six years since his marriage, Osbert described his life as 'being happily engaged in writing books, begetting children and

'There's only one solution: we must by-pass the by-pass.' (19 January 1939)

In August 1939, to mark the German-Soviet Pact, Osbert drew Hitler and Stalin shaking hands beneath their respective flags. There is no caption, Osbert merely swapped their moustaches.

drawing architecture.' His family life was exceptionally content. His daughter Cara was born in 1934, followed by his son William three years later. The arrival of the children necessitated a move in 1935 from the top floor mansion flat to a house at 10 Addison Crescent. Long summer holidays were spent with Karen's parents on the Isle of Wight where Cara Harris, having become an addicted cineaste, cast all and sundry in a number of full-length films.

Just before the war, one other significant development occured in Osbert's career. Thanks to John Betjeman, he picked up his first job in Fleet Street by agreeing to help him write a series of articles for the *Daily Express*. A friendship developed with John Rayner, the features editor and typographer who had recently redesigned the paper. One night after dinner, Osbert mentioned his admiration for 'the little column-width cartoons' published in the French papers, but which had never been adopted by their English counterparts. 'Go ahead,' was Rayner's instant reaction, 'give us some.' On 1 January 1939 the first ever pocket cartoon, so called after the pocket battleships, much in the news at the time, appeared in an English newspaper. Its position was on the William Hickey gossip page of the *Daily Express,* which was written by Osbert's old Oxford friend Tom Driberg. Later it was promoted to the front page. Early topics touched on his architectural preoccupations. One depicts two town planners studying a map, saying: 'There's only one solution: we must by-pass the by-pass.' Inevitably, the international situation predominated, although he was initially constrained by Lord Beaverbrook's line that war was impossible. Only after the occupation of Prague was Osbert given free rein to attack the leaders of the Thousand Year Reich. In August 1939, to mark German-Soviet pact, he drew Hitler and Stalin shaking hands beneath their respective flags. There was no caption, Osbert merely swopped their moustaches.

This was not the first time that Osbert had noted the similarities between the two dictatorships. In *Pillar to Post*, he had illustrated a fascist building entitled Third Empire and a Soviet one entitled Marxist Non-Aryan. They are identical apart from a few unimportant details' sharing 'the same emphasis on size, the same declamatory and didactic idiom.' He concluded: 'the proletarian and the fascist both labour under the same misapprehension – that political rhetoric is a sufficient substitute for genuine architectural inspiration.'

Osbert's antennae regarding current affairs were far less acute. Prior to landing his unexpected job on the *Express,* Osbert rarely read the papers. His detachment had led him to remain 'obstinately neutral' on the divisive issue of the Spanish Civil War. He had also remained sanguine on

the developments in Germany, preferring to believe that radical artistic movements led by the likes of George Grosz and Kurt Weill in Berlin and the satirical publication *Simplicissimuss* in Munich provided a 'built-in opposition to the nightmare ascendancy of lower middle-class nationalism.' Occasionally, he was unnerved by incidents of Nazi arrogance on his travels in Germany but it was not until Munich that reality dawned.

Osbert signed on at his local Air Raid Warden's Centre, but otherwise life – on the surface – went on as usual. Early in August 1939, he and Karen escaped to Normandy to satisfy his latest craving, which was for the Romanesque. Their return coincided with the announcement of the German-Soviet pact. Two weeks later on the 2nd September, after a night of eerie gaiety at the Café Royal, he turned up at his A.R.P. Post to be told to report again the next day at 1.00 o'clock. On his way there, he dropped in on the public bar at the Holland Arms to listen to the news. Hitler had not withdrawn from Poland so war had been declared.

THE WAR YEARS

Within three months of the outbreak of war, Osbert landed a job in the Ministry of Information, a vast new bureaucracy spanning numerous departments and housed in the Senate House of the University of London. Thanks to his languages and journalistic experience, he was recruited to work for the department responsible for the release of overseas news to the British press and, as part of the propaganda war, to enemy, neutral and allied nations. This was to be his official wartime occupation for the next five years, even though the Ministry itself lost out in the 'Battle of Bloomsbury' waged with Whitehall rivals in July 1941, and Osbert's department fell to the Foreign Office. As a result, he was transferred to the F. O. News Department. His place of work, however, remained the Senate House.

From the start, the corridors of the Ministry had swarmed with writers and journalists. Some months into his assignment, Osbert reported on the latest state of affairs to Jock Murray: 'the M.O.I.,' he wrote, '… still retains its old and, to my mind, most important function as providing a Home of Rest for intellectuals in war-time. Our latest inmate is old P.Q. [Peter Quennell] so that now, what with J.B. [John Betjeman], Harold N. [Nicolson], Raymond Mortimer etc. etc. there exists quite a considerable band of stalwarts pledged to maintain the highest traditions of undergraduate life of the roaring twenties.' John Betjeman, who was working for the Films Division, always came up trumps. 'On one occasion,' Osbert recalled, 'we returned to the Senate House after lunch and the armed guard

'Sometimes Ulrick, I get so depressed that even thinking about the next war doesn't cheer me up.'
From *Assorted Sizes* (1944)

on duty asked John if he might see his pass. "No you can't" John said "I'm a German spy." '

The onslaught of the Blitz meant that the Senate House became the place where, in Osbert's words, 'we work, eat, sleep and have our being.' Dormitory life in the overcrowded basement was 'wonderfully bizarre'. 'There, picking his way delicately, albeit somewhat bad temperedly, one may observe Sir Kenneth Clark with a seventeenth-century folio under one arm and a set of pale blue *crêpe de chine* sheets over the other searching where he may lay his head.' Meanwhile, Osbert's immediate superior, Harold Nicolson, 'wistfully complaining of his wretched claustrophobia', risked spending the night on the first floor, where he typed his diary 'as the guns boomed'. Osbert himself cut a considerable dash during Britain's darkest hour. Michael Bonavia, a senior official of the University of London, recalled that: 'One night there was a particularly loud bang nearby and, getting up to investigate, I encountered in the corridor Osbert Lancaster – black moustache, eyebrows and all – gorgeous in a superb plum-coloured silk dressing gown, looking exactly like the villain of some Victorian melodrama.'

One of Osbert's propaganda booklets in Dutch (front and back covers).

Charles Holden's recently completed Senate House with its central tower of gleaming Portland stone proved an irresistible target for the bombers. One 'really dirty night', Osbert was seriously shaken by the second of two hits, which 'arrived at the bottom of an interior well precisely at the moment when I had reached the bottom of the staircase alongside. Thanks be to God the intervening wall held, for this was a projectile of far from modest calibre.' At last, he felt equal to his friends in uniform.

For Osbert, the most depressing part of the day was surveying the damage of the previous night. '… too often the Banker's Georgian is spared,' he lamented, 'and some charming inoffensive little row of eighteenth-century houses have coughed out their bowels into the street.'

As the chequered course of the war unfolded, Osbert proved an adept performer in the various roles demanded by his job. As a key figure in controlling the dissemination of news, he was the urbane spokesman for the Foreign Office at the regular Duty Room meetings when civil servants from other sections were briefed on the progress of foreign campaigns. The British press proved more testing. He found it a 'very great strain' having to explain government policy in the Far East to journalists whom he defined as 'left wing, invariably, and unsympathetic, usually'. Osbert also worked shifts monitoring German news bulletins which, one midnight, involved him springing into action over 'a lot of rude stuff' put out about the Windsors.

His own talents as a cartoonist were not neglected. Complaining to

Jock Murray of his heavy workload, he explained: 'I am also doing lots of drawings for the propaganda boys.' Peter Quennell, a humble press censor, who longed to become a 'master propagandist', wrote enviously that Osbert was 'attached to the Bedfordshire country house [Woburn Abbey] where the ministry conducted its most secret campaigns to undermine the enemy's morale.' One of their weapons was a leaflet dropped over Germany and occupied countries illustrated with cartoons by David Low, Osbert and his fellow *Express* cartoonist, Walter Goetz. Two booklets of anti-Nazi cartoons by Osbert with captions printed in Dutch and French were also produced for aerial drops.

As if his war work was not sufficient, most days Osbert continued to draw pocket cartoons for the *Daily Express* on the Foreign Office's best cream-laid minute paper, which were sent round by government messenger to Fleet Street. They proved so popular that in March 1941 he was able to renegotiate a far more favourable contract with the paper. His productivity was upped still further in July 1943 when he started contributing a larger cartoon regularly to the *Sunday Express* under the name of Bunbury. Each November from 1940 to 1944 collections of his cartoons were published by John Murray. As a measure of their success, the 1941 collection entitled *New Pocket Cartoons* was reprinted in the month of publication.

In the introduction to his first collection, Osbert highlights the plight of his European peers. 'It is a chastening thought – at least for the cartoonist,' he wrote, 'that during this period so many admirable comic artists have been banished from the world's press.' He singled out as victim, 'the finest satirical draughtsmen in Europe', the artists who had worked for the pre-war German publications *Simplicissimus* and *Berliner Illustrierte*, and he anticipated a similar fate for the 'witty scribbled margin drawings of the French and the careful and sincere full-page productions of the Dutch.' The artist, he concluded, must be grateful for his freedom 'to draw and publish whatever, within reason, strikes him as funny'. Equally, he points out, the reader should be grateful that 'he is as yet neither forced to buy this book nor to laugh at the jokes which it contains.'

There was nothing forced about the laughter that greeted Osbert's cartoons. He turned the Germans into figures of fun, particularly Marshall Goering with his 'never receding girth' and, at the time of invasion scares, German parachutists and undercover agents. A parachutist dressed in top hat and formal clerical garb commands his inferior, disguised as a humble vicar, as they float down to earth: 'Do not forget, *meine Soldaten*, that from now on I'm Herr Archdeacon to you.' Osbert had a particularly good line in Nazi children. One shaven haired little brute boasts to another, 'You

Jacket for *New Pocket Cartoons* (1941).

'*Do not forget,* meine Soldaten, *that from now on I'm Herr Archdeacon to you.*' (1940)

'Don't give it a thought, boss – it's just an old Jewish gag.' From Assorted Sizes (1944) under the name of Bunbury.

only got your Daddy sent to Dachau. When I denounced Granny, she was shot.' The Italians come in for similar stick. A prisoner, who has downed his agricultural tools, is informed by a west-country farmer: 'I dessay it's different in the Isle o'Capri, but in Shepton Mallet we don't 'ave no siesta hour.' Of course, the British under arms provided plenty of ammunition. A favourite theme was the women's services. He loved drawing beefy members of the ATS or the Wrens with lantern jaws, immaculately turned out in their mannish uniforms.

The larger cartoons in the *Sunday Express* gave Osbert greater scope as a graphic artist. The Germans' retreat from Russia, the collapse of Vichy France, the liberation of Rome inspired a series of powerful, often savage, images which expose his loathing of the Nazis. One of the most chilling cartoons depicts Hitler and his henchmen feasting on lobster and champagne. On the wall, the hand of God writes, 'Mene Mene Tekell… ', at which Herr Goebbels is seen turning to a glaring Hitler with the words: 'Don't give it a thought boss – it's just an old Jewish gag.'

Over forty years later, Osbert's achievement as a wartime cartoonist was saluted by Anthony Powell. 'Lancaster', he wrote, 'was an immediate, indeed often daily, producer of his art which not only commented on the war but kept people going by his own high spirits and wit … he should certainly be thought of as a war artist.'

In 1940 the Lancasters had dispatched Cara and William to live for the duration in Washington DC, with Osbert's old friend from Oxford days Angus Malcolm. The house in Addison Crescent was closed up and the Lancasters decamped to a cottage in the Berkshire village of Aldworth,

which they shared with the cartoonist Walter Goetz and his wife Toni. The greatest benefit to come from this temporary arrangement was Osbert's meeting with the artist John and Myfanwy Piper who lived at Fawley Bottom on the other side of the Thames.

Pony trap at Fawley Bottom Farm with (left to right) John and Myfanwy Piper, Karen and Osbert.

Piper was five years older than Osbert and one of the most esteemed contemporary artists in Britain. His reputation had been established in the mid-thirties as a leading exponent of abstraction. As the decade had worn on, though, his artistic allegiance had swung towards representational art, inspired by his lifelong passion for the topography and architecture of Britain. His close friend John Betjeman had greatly encouraged him along this path. It was at his suggestion that Osbert had bicycled over to Fawley Bottom to introduce himself. 'We got on like a house on fire,' Piper recalled of their first meeting. Osbert, in turn, thanked Betjeman for his intercession, writing: 'What a service you did us the day you brought the Pipers into our lives.'

Osbert enthused in a *Spectator* review of an exhibition of war paintings at the National Gallery that Piper's 'Coventry' was 'a staggering production, a crackling, molten *tour de force* which, I am convinced, could have been produced by no other living artist.' The astute chronicler Anthony Powell, who used to meet the Pipers with Osbert after the war, summed up their relationship. Piper, he observed, was 'a great friend of Osbert, who was distinctly in awe of him.'

In the autumn of 1941, the Lancasters briefly moved in with the Pipers, but Myfanwy's impending confinement signalled a return to London. Their latest home was a minute flat with wafer-thin walls in a modern 'cliff-like seven-hundred-cell honeycomb' on the Edgware Road. In short, Osbert wrote, 'the acme of domestic comfort'. Osbert's art had anticipated his life. He had ended up in a version of the Luxury Flat described in *Homes Sweet Homes*.

Wartime London provided fertile territory for Osbert's love of gossip. In a letter to Jock Murray, he described chatting about air raids to a 'vaguely

familiar blonde' at dinner chez Nancy Mitford. 'This she seized on', he related, 'and in an intense, wrapt voice told me how frightened she always was on such occasions. Which, she went on, was all the odder as she wished very much to die. Upon my looking a trifle blank at this revelation delivered across the soup, she qualified this by saying: "Ever since I tried to commit suicide you know." Suddenly it dawned on me that this doomed cow-like creature was none other than Unity.' His love of careless talk occasionally took its toll. Having revealed to Jock Murray the latest details of Peter Quennell's sex life and concluded with the moral, 'she is a prize bitch, and he... a first class sucker', he hastily added in a fit of guilt: 'the scabrous details about PQ, it now occurs to me, were revealed to me in strict secrecy... so for heaven's sake keep them to yourself.'

Osbert's war service in London came to an abrupt end in December 1944, when he was posted by the Foreign Office to serve as Press Attaché to the British Embassy and GHQ in Athens. His appointment was a response to the sudden descent by Greece into civil war, which threatened not only the newly installed provisional government but the small British force sent to maintain order following the withdrawal of the Germans.

A military presence was essential given the known ambitions of the communist resistance movement in Greece whose long-term goal was to transform Greek society along Soviet lines. They had already attempted to liquidate 'rival' guerrilla movements but a truce had been patched up by the British.

The first fighting of the Greek Civil War broke out on 3 December when the police fired on demonstrators in Constitution Square, killing twenty people. Whether they had been provoked remains obscure. Osbert later maintained that a communist insurgent on his way to the demonstration had tossed a hand grenade through the first floor window of Prime Minister Papandreou's flat. These deaths handed ELAS, the military wing of the communist party, their first victory: The British and American press, already hostile to British intervention, were outraged. *The Times* was particularly critical opening its report: 'The seeds of civil war were well and truly sown by the police of Athens today.' Harold Macmillan, whom Churchill had made 'Viceroy of the Mediterranean', aborted a planned visit to Washington and returned forthwith to Athens accompanied by General Alexander, Commander-in-Chief of Allied Forces in the Mediterranean.

While work was continuing on strategy in the embassy, the communists were drawn up about two hundred yards in front of the building on the other side of the Ilyssus River. All the ground immediately behind it on the lower slopes of Mount Lycabettus, was also in their hands. On Macmillan's

second night, a rebel force rushed the HQ of one of the armoured brigades, about three hundred yards from the embassy. Fighting continued through the night and into the following day until the communists were eventually thrown out, taking with them around a hundred prisoners. Meanwhile, the RAF broke up a large formation in the Stadium to pre-empt a frontal attack. It was on this day, 13 December, that Osbert flew into Athens.

His arrival was greeted with relief by Macmillan, who as a target of communist fire was much exercised by the negative attitude of the British and American press. As the fighting raged around him, he telegrammed London about *The Times* representative, 'a disgracefully incompetent and foolish fellow', and on the press and Americans generally. In his diary he wrote, 'Osbert Lancaster has arrived as Press Attaché. He will be a tower of strength and common sense.'

Osbert became the latest to join the uncomfortable life in the beseiged embassy, where fifty people were living and sleeping. So exposed was the building that no one was allowed outside; even the small garden could only be reached at risk of sniper fire. The front rooms had been evacuated and beds lined the passages. Osbert was allocated a bed in an office. There was no heat, light or water, though fortunately all the baths had been filled and there was a lily pond. Macmillan thought the circumstances evoked chilling parallels to the siege of Khartoum in which General Gordon had met his fate. Osbert drew a lighter comparison to one of his favourite novels, *The Prisoner of Zenda.*

Over the next few critical weeks, Osbert set out to pacify the hostile ranks of the press corps, billeted in the Hotel Grande Bretagne. Having had five years experience of parrying the demands of journalists in the thick of war, he was the ideal man for the job. One of his most effective weapons was charm. Richard Capell of the *Daily Telegraph* described his technique: 'Merlin-wise, he begins his pronouncements at our conferences thus: "Not to prevaricate, gentlemen, the honest truth is…" or "To speak with perfect frankness little can be said beyond what already in your devious ways you have… ". ' An Australian journalist recently arrived in Athens considered cutting Osbert's next press conference only to be told by a colleague: 'Oh, don't do that. They're hilarious. We wouldn't miss them for anything. They're held by a man called Osbert Lancaster, and we've never been to briefings like them.' That day he opened with the words: 'Well, I'm afraid I have absolutely no news today, so I'm wondering what you can tell me.' Often, his explanations were supported with humorous drawings on the blackboard, such as Evzonoi (traditional infantrymen in fustinella) with muskets. Two troublesome journalists, Geoffrey Hoare and Marcel Fodor, found

Osbert's silhouettes
of the Holy Family, the
shepherds and kings,
cut out of card with
nail scissors. Athens,
Christmas 1944.

themselves caricatured as Don Quixote and Sancho Panza when Osbert
heard about a mission of theirs to assist a woman in prison.

Beneath Osbert's jokey manner lurked a steely determination
to counter the pro-communist bias of the international press. The
importance of this role was reflected in his more shadowy support for the
military operation, which involved 'fulfilling a multitude of extraordinary
functions'. He outlined his status to Jock Murray: 'I wrestle with brigadiers
and chastise majors in my capacity as a member (exact rank unspecified
but generally thought to be above a full Colonel) of GHQ.' He also was
involved with military propaganda and his influence pervaded the military
censor's office. Strategically, his most significant contribution was insisting
on having a guard mounted, 'not a moment too soon', on the Acropolis.
For over a week, a handful of paratroopers held the summit against
repeated attacks.

As the fighting continued, decisive measures were taken to improve morale.
Macmillan broke into the personal wine cellar belonging to the previous
ambassador, overriding the current ambassador Rex Leeper's disapproval
with an order scribbled down as another burst of machine gun fire hit the
building: 'I have decided that in sieges it is permissible to drink the former
Ambassador's champagne. Harold Macmillan, Secretary of State.' Osbert
said 'life was more bearable after that.' He was often in attendance on the
Secretary of State. 'I listen for hours on end to Macmillan thinking aloud',
he wrote to Jock Murray, 'a wearing but not unprofitable employment.' One
evening Macmillan entertained him with a reading of Thucydides' account
of the revolt of Corcyra in which he substituted the names of all the most
untrustworthy politicians in Athens with those in the text.

The military situation improved, but the political strategy remained
stalled. It would, Macmillan wrote, 'be a grim Christmas'. However, any
household including Primrose Leeper, the Ambassador's wife, and also
Osbert Lancaster was bound to enjoy some festive cheer. She fabricated
little Christmas trees 'out of nothing' and he cut out from index cards
silhouettes of the Holy Family, the shepherds and kings. Midnight mass
was celebrated in the drawing room by an army chaplain who had arrived
by armoured car. In his sermon, he referred to the Herald Angels as 'God's
Airborne Division'.

Churchill with Archbishop Damaskinos, head of the Orthodox Church in Athens (Osbert is on the far right at the back).

Christmas morning saw Osbert at the Grande Bretagne sharing a demijohn of retsina with the war correspondents 'upon which, by some undisclosed chicanery, they had managed to lay their hands.' On his return to the Embassy he found that Churchill was due to land in Athens in a few hours time. Churchill who had spent the night on a cruiser stationed off Piraeus arrived at the Embassy on Boxing Day. Osbert, who had last seen him at close quarters three years previously, noticed a marked change: 'His face seemed to have been moulded in lard lightly veined with cochineal and he badly needed a haircut.' However, 'the sound of mortaring and rifle fire, combined with the historic associations of the countryside… were clearly already having a tonic effect.' His presence at a hastily summoned conference between all the warring political parties, as well as ELAS, had an equally restorative effect and led to the commencement of political dialogue.

The following day Osbert was responsible for arranging a press conference for the Prime Minister. The Americans, in particular, were insistent upon taking photographs which necessitated posing – for reasons of light – in the garden. Although the garden was safe, its access, via a small platform outside the drawing room window, remained exposed to the snipers' line of fire. Osbert only persuaded the Prime Minister's security officers to agree to the manoeuvre by light-heartedly accepting personal responsibility for his safety. He then foresaw a snag which necessitated a hasty appeal to the photographers. He begged them not to rush forward as Churchill stepped onto the platform, as this would undoubtedly lead him to stop dead in a suitably aggressive pose. Everything happened exactly as he had feared: 'The photographers', he recalled, 'rushed forward, the Prime Minister stopped dead and a short crack followed by a shower of plaster announced that a bullet had hit the wall two feet above our heads.' Summoning all his courage, Osbert gave the infuriated Prime Minister a sharp shove in the back, precipitating him down the steps into the garden.

Church near Koropi, Attica.
From *Classical Landscape
with Figures*

In retrospect, Osbert considered this to be one of his most effective
contributions to the war effort.

Churchill's airborne diplomacy broke the political deadlock. Over the
ensuing weeks a truce was negotiated and in February 1945 a political
settlement agreed. Osbert, who remained close to the heart of events,
likened the resulting transformation of life in Athens as moving from
Anthony Hope's *Prisoner of Zenda* 'into the world of Saint Simon – of
rival archbishops, intriguing generals, of Prime Ministers' mistresses, and
éminences grises of every shade.' He remained *en poste* at the British Embassy
for a further year until a measure of political stability had been achieved.
The coming of peace saw a flock of pre-war exotics arrive in the capital,
Byronic hero of the Cretan resistance Patrick Leigh Fermor, litterateur Rex
Warner, youthful artist Johnny Craxton, surrealist photographer Joan Rayner,
Byzantinist Steven Runciman and dandy Hellenist Mark Ogilvie-Grant. They
and their Greek peers, painter Nikos Ghika, poet George Seferis and writer
George Katsimbalis formed Osbert's highly cultivated circle.

Another reward of peace was the opportunity to travel outside Athens.
By the end of his stay, Osbert had explored Attica, Boeotia and Arcadia,
and made forays into Thessaly and Epirus as well as to some of the islands.
Throughout his travels, he had an artistic goal in mind. Writing to Jock
Murray in the autumn of 1945, he announced: 'I fully intend a little work
on Greece and have already filled one notebook full of drawings but have
not yet started to write. I visualise something in between a guide book and a
travel book, rather in the 18th-century topographical style.'

The result was a thoroughly up-to-date account of Greece, belied by
its title *Classical Landscape with Figures*, which was published in October

The ruins of the church of Agia Sophia, Andravida. A Frankish foundation in the Gothic style. From *Classical Landscape with Figures*

1947. It opens with a light-hearted analysis of the Greek temperament as expressed through politics, religion and society before turning to the history, topography and monuments of the country limited, of course, to the extent of Osbert's travels.

His historical scope, which gives due emphasis to the Byzantine, Frankish and even Wittelsbach eras as well as to the Classical, reflected the scholarly revisionism and changes in taste which had been gathering pace until stalled by the war. Osbert's enthusiasm for Byzantine architecture and mosaics, first lit by Robert Byron's earlier advocacy, ensured that his emotions were stirred more intensely by those than by the familiar landmarks of ancient Greece. As fresh for the post-war reader were his glimpses of the courtly life of the Franks. Osbert's most original historical contribution was sparked by his habitual interest in nineteenth-century stylistic developments. The arrival of the Wittelsbach King Otto in 1827, along with his Bavarian neo-classical architects, launched Osbert on an informed account of the growth of Athens from the public buildings programme dating from Greek independence to the creation of the pre-war housing estates built for the refugees from Asia Minor who arrived in 1922. Osbert's investigation of modern Athens even resulted in the cataloguing of two previously unknown styles – Hollywood Balkan and Minoan Revival.

His survey of Greece included the legacy of the Occupation. He described the fading gothic lettering on the walls of tavernas in Attica, the crumbling slit trenches at the Mycenean citadel of Asine, the sculpture of Hermes at Olympia 'swathed in sandbags and bricks' and the bomb damaged eleventh-century monastery of Osios Loukas. He also counted the human cost. The village of Distomo on the Boeotian plain he depicted as a place where 'almost every house still standing within the ruins exhibits crosses scrawled in blue paint beside the door, together with the names of inmates whom the Germans took out and shot in the market place.' These were not the only scars etched into Osbert's classical landscape. He also

Pru Wallace

detailed the massacres and abductions carried out by the communists in the civil war. By highlighting the inherent danger of communism he used the medium of his enjoyable travel book to continue the war of words first waged by him during the siege of Athens. Since then the position of Greek democracy had become even more fragile. Once again civil war was tearing the country apart, fomented by Greece's communist neighbours. The country had become the first battleground of the Cold War – and Osbert one of the earliest recruits to the cause of the West.

AFTER THE WAR

Osbert viewed the consequences of peace with mixed feelings. In his final months in Athens he unburdened himself to his old friend Jock Murray: 'Do you,' he asked, 'like me, find yourself suffering from a post-war, century-of-the-common-man, atomic hangover? My depression is profound tho' there are I must admit, personal as well as global reasons.' Osbert, who had been apart from Karen for over a year, had fallen in love with a war widow called Pru Wallace who had originally trained as an actress with the Old Vic company. Her husband had, ironically, served as Press Attaché to the British Embassy in Athens at the start of the war. The couple had been evacuated to Alexandria before making their way back to England where Pru had two daughters. She returned with them to Athens in 1945 to retrieve possessions from their pre-war house and to work for the British Council. One of her tasks was assisting Osbert in setting up a visit to London for the artist Niko Ghika. Osbert was smitten with her striking looks, thespian background, intelligence and love of Greece. He revealed his anguish in an apologetic letter to Jock Murray: 'The reasons for my silence are manifold,' he explained, 'pressure of work, emotional crises, and a prevailing uncertainty as to the future which make it very hard to know quite what to say.'

Equilibrium was restored with the arrival of Karen in Athens. Indeed, the Lancasters shared a house with Pru and her girls in the city. The connection continued in London, where Pru stayed with the Lancasters in Addison Crescent. Later she married a Welsh landowner, Gerry de Winton, and the two families remained friends. Osbert marked his attachment to Pru by dedicating *Classical Landscape With Figures* to her.

Back in London, Osbert resumed his pre-war career as cartoonist, journalist and illustrator. Two slim, illustrated volumes also rolled off the press. The first, in 1948, was a children's book, dedicated to Cara and William, entitled *The Saracen's Head*. It was the tale of a reluctant crusader William de Littlehampton who, despite his incompetence at all manly pursuits, went on to win fame and glory in the Holy Land. The second,

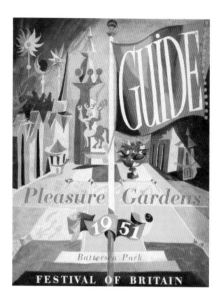

Guidebook to the Battersea Pleasure Gardens, Festival of Britain 1951.

published the following year, was *Drayneflete Revealed*, an architectural satire in the manner of *Progress at Pelvis Bay* which, in this case, was composed as a pedantic local history. A series of brilliant illustrations accompanying the text chart, in compelling and often mordant detail, the changes imposed on the town of Drayneflete and its environs from the Bronze Age to the present day. The final image of the town, 'The Drayneflete of Tomorrow', presents a chilling vision: wholescale demolition has taken place and the ancient street pattern has been obliterated. Instead, the townscape consists of dual carriageways, clover-leaf and high-level pedestrian crossings, tower blocks and a landmark amenities centre. Two historic monuments survive: one, the Tudor gatehouse, isolated on a roundabout, the other, the Parish Church, stranded in a vast open space, each is merely labelled 'Cultural Monument scheduled under National Trust'.

As a corrective to this Corbusian nightmare, soon to be inflicted in reality on historic towns across Britain, Osbert teamed up with John Piper to work on the Festival Gardens in Battersea Park, which had been conceived as an antidote to the more serious and educational exhibitions to be found at the Festival of Britain in 1951. Whereas the South Bank with its astonishing Skylon and collection of radical pavilions and halls stood for contemporary style, the Festival Gardens were intended to evoke the spirit of eighteenth-century pleasure grounds such as Vauxhall and the Belvedere. It was to be a place of 'elegant fun' with a dance hall, amusement park, shopping parade, restaurants, pubs and a wine garden. Osbert was ideally equipped to follow this brief.

A playful spirit suffused his and John Piper's designs for the Grand Vista of the Festival Gardens, a formal arrangement of pools, arcades, pavilions, obelisks and towers. Their chosen architectural style was Chinese gothic, an old favourite of Osbert's, first mentioned in his 1936 article 'The Glamorous East' with a photograph of a garden temple 'that shows a happy blend of

'The Drayneflete of
Tomorrow'. From
Drayneflete Revealed
(1949)

Gothick and Oriental motifs'. More recently, he had illustrated another example in *Drayneflete Revealed*, the now demolished 'Lord Littlehampton's folly', which had incorporated five different styles in its design including 'a gothic octagon, pierced with traceried windows and sustained by flying buttresses, supporting a three-storied Chinese pagoda'.

In the run-up to the opening, the construction of the gardens was delayed by weeks of torrential rain, strikes and financial mismanagement. *Harper's Bazaar* predicted: 'Still sunk in primeval slime, it seems that the Pleasure Gardens can never be more than a lovely mirage in the minds of Piper, Lancaster and the other artists who imagined them.' Their pessimism was overdone. The gardens opened in the summer of 1951 and attracted eight million visitors in the first few, damp weeks.

This was not the only fantasy that Osbert summoned up in celebration of the Festival of Britain. Through Piper's introduction, he was invited by the young choreographer John Cranko to design the sets and costumes for *Pineapple Poll*, a new ballet based on a ballad by W. S. Gilbert and a selection of Arthur Sullivan's music. Its comic plot, 'robust and highly inventive dances', brilliant arrangement by Charles Mackerras of Sullivan favourites, and Osbert's radiant nautical and architectural backdrops plus jolly costumes for the jack tars turned *Pineapple Poll* into the theatrical hit of the Festival. As a result Osbert was launched at the age of forty-three on a fresh career which turned him, almost overnight, into one of Britain's most sought after designers of theatre, ballet and opera.

His success was no fluke. 'The theatre', he once explained to Moran Caplat, General Manager of Glyndebourne, 'holds no terrifying mysteries for me.' Even as a child, Osbert had observed life as though from the stalls. His perambulations through the streets of Notting Hill were for him a theatrical experience to be stored away in his remarkable visual memory. One such moment, recalled in a memoir written at the time of his earliest

Lord Littlehampton's
Folly incorporating the
Chinese Gothic style.

commissions for the ballet, visualises Holland Road as a backdrop 'framed by the wings of its long stucco perspectives', setting the stage for 'the seething Saturday night crowds. . . women all in tight sealskin jackets and vast plumed hats. . . men in pearl buttoned waistcoats and flared trousers, jostling round the street market in the theatrical light of the gas-jets'.

This dramatizing instinct had been nurtured by frequent outings with his mother to the theatre, music hall, and ballet. Much of his subsequent work in the Studio at Charterhouse was devoted to composing 'large historical or oriental scenes' heavily influenced by three of the great designers of recent times, Old Carthusian Lovat Fraser, described by Osbert as 'an idol of his youth', the French illustrator Boutet de Monvel, and Diagilev's designer of genius, Bakst.

He deepened his knowledge of Diaghilev's Russian Ballet on his annual visits to stay with the Van den Eckhoudts, which often coincided with the company's season at Garnier's extravagant nineteenth-century theatre in nearby Monte Carlo. Night after night, he would attend performances of the company's greatest productions, including ballets rarely if ever seen in London, such as *Pulcinella* by Stravinsky and the *Triumph of Neptune* by Berners and Sitwell, both with designs by Picasso. On one memorable evening, Osbert caught sight of the Master himself, plain and monocled, 'hurrying through the respectful throng with an anxious cortège of aides de camp... like some Napoleonic marshal striding through the glittering ante-rooms of a requisitioned Schönbrunn.'

Osbert's studies at the Slade under Vladimir Polunin, who had been Diaghilev's principal scene painter, were also helpful to him. Although Osbert claimed that Polunin's instruction, which was based on the Continental method, was of limited use in English theatres, he maintained that 'my happiest hours by far were those spent in the department of stage-design.' He had certainly learnt the practicalities of the discipline – how to handle distemper and mix size – which, he admitted, 'stood me in good stead many years later when I found myself quite capable, should the need arise, of painting a sky border or finishing off a backcloth single handed.' Early evidence of his scenic gifts was revealed in a series of murals completed in July 1935, now concealed, for the Assembly Room at the Crown Hotel in Blandford Forum. Assisted by Karen, he executed a scheme of highly theatrical compositions inspired by the Regency, including a warlike Prince Regent astride a grey charger and Napoleon surveying the English Channel with a group of military advisers, their helmets and shakoes adorned with magnificent plumes.

Two years before the launch of his own career, Osbert wrote a fusillade

John Cranko working with Osbert on the designs for *Bonne Bouche*.

in the *Spectator* attacking the current state of theatre design in Britain. He had in his sights the 1949 production of the *Marriage of Figaro* at Covent Garden, produced by a precocious Peter Brook. In a sizzling critique, he mocked the historical inconsistency of the costumes which ranged from nineteenth-century shepherds and shepherdesses to Spanish dancers from 'a hundred posters for invalid port' to the duenna, Marcellina, draped in a mosquito net. The scenery was no better. The final backdrop was a deep blue sky against which, he suggested, 'one momentarily expects to see a thin plume of smoke spell out the name of a popular brand of cigarettes.'

The moral to be drawn from such visual confusion, he argued, was that fantasy on the stage can only ever be convincing if the production is 'completely consistent in every detail and is the work of a designer with a sense of style amounting to genius.' As a life-long connoisseur of periods and styles, Osbert, the most modest of men, was, in effect, describing his own particular gift.

Following the success of *Pineapple Poll*, John Cranko immediately commissioned him to design another comic ballet, *Bonne Bouche*, which was premiered in 1952 at Covent Garden. The farcical plot required Osbert to conjure up the worlds of both fashionable Kensington and the African jungle. Critics and audience alike were enchanted. *The Sunday Times* hailed it as:

Part of a mural completed in 1935 for the Assembly Room at the Crown Hotel in Blandford Forum. This illustration shows Napoleon surveying the English Channel with a group of military advisers.

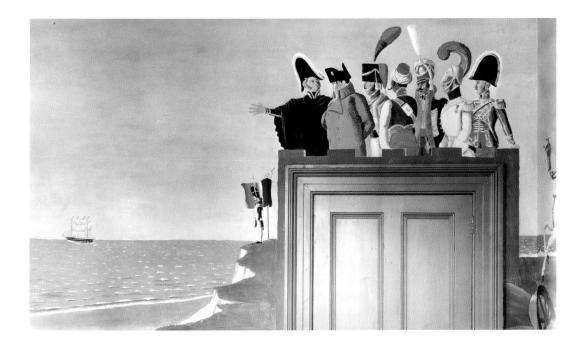

'among the gayest and most captivating ballet sets ever designed by an English artist.' Osbert had triumphed in what he perceived as the prime duty of the theatrical designer towards his audience, 'to tempt the mind out of itself and send it forth upon the first stage of its journey into the world of illusion.'

Over the next ten years Osbert designed the sets and costumes of fifteen productions of ballet, opera and the theatre. He became one of the principle designers for Sadler's Wells Ballet at Covent Garden, working on classics such as *Coppelia* and *La Fille Mal Gardée*, and for Glyndebourne Festival Opera, where his credits included *The Rake's Progress*, *Falstaff* and *L'Italiana in Algeri*; he also undertook projects for Benjamin Britten and Leonard Bernstein. The most prominent theatre company to employ him was the Old Vic, for productions of *All's Well That Ends Well* and *School for Scandal*, but he also worked with such comic stars as Alec Guinness, Irene Worth and Douglas Byng. After 1960, the pace slackened. His last commission, in 1971, was Gilbert and Sullivan's *The Sorcerer* for the D'Oyly-Carte company, rounding off a career which had been launched by the work of the same duo twenty years earlier.

In a lecture on stage design delivered towards the end of his prolific career, Osbert revealed his technique for pulling off 'this extremely difficult operation'. Not only had he to create for the audience the 'illusion that one can freely pass' into a recognizable world presented on the stage, but that everything in that world 'must be slightly larger, brighter, or more sombre than in life.' This need for exaggeration, essential to stage plays, was 'even more forcibly' applicable to opera and ballet. Comparing Shakespeare's *Merry Wives of Windsor* to Verdi's *Falstaff*, he argued: 'If, in the *Merry Wives of Windsor* Herne's oak must be larger, older, and more sinister than any tree to be found in Windsor Forest – then in *Falstaff* it must be a veritable Yggdrasil' (the archetypal World Tree of Norse mythology). His own depiction of Herne's Oak at Glyndebourne was a triumph. Moran Caplat recalled that the last scene 'with Herne's oak and the river glinting in the background had a real magic. [It was] a miracle of touching natural beauty without a hint of satire.' Osbert's gifts as a caricaturist assisted his powers of exaggeration, but never undermined the artistic unity of the whole.

Osbert went out of his way to respect the intentions of producers. One of his closest collaborations was with Frederick Ashton on his ballet, *La Fille Mal Gardée*. Unlike many choreographers, Ashton knew exactly what he wanted and how to turn his vision into a brief. 'There exists in my imagination a life in the country of eternally late spring,' he wrote of the idea for his ballet, 'a leafy pastorale of perpetual sunshine and the humming of bees.' As illustration, he lent Osbert a series of nineteenth-century prints

Osbert with Moran Caplat, general manager of Glyndebourne, who at Osbert's memorial service observed: 'I do not believe that in any case where I have seen the work of other designers applied to the same piece, I have ever seen Osbert surpassed in overall grasp of the truth of the matter.'

of English country life. Osbert's design, which remains in production after almost fifty years, is testament to the authenticity of his realization of Ashton's dream.

Osbert was in his element backstage, cheering up the cast and crew with jokes about the critics or adorning the wardrobe room with cartoons and caricatures. As befitted one of the wittiest men in England, almost all of Osbert's commissions were, in one form or another, comedies. His friend and fellow artist, John Craxton, defined his brilliance thus: 'Osbert was able to make theatrical jokes without being too cartoony – he was accurate, but not academic. His work was full of *joie de vivre*. When he drew a building, such as the lovely church in *Pineapple Poll*, he knew exactly what he was doing. The pleasure one gets from seeing his sets – like those of Hockney – is having the thrill of seeing him render *le mot juste*.'

Capturing *le mot juste* was also the key to Osbert's success as a cartoonist, which reached new heights in the post-war years. Having suspended work in December 1944 on his posting to Greece, he resumed production of the pocket cartoon for the front page of the *Daily Express* eighteen months later. Thereafter he scarcely missed a day until the end of the nineteen seventies. In the collected editions of his cartoons, Osbert described his occupation as being akin to an anthropologist conducting fieldwork into the social life of mid twentieth-century England.

Others drew different conclusions. His achievement, as the journalist Peter Grosvenor put it, was chronicling 'a history of our troubled times illuminated by his unique wit and humour.' From the Berlin airlift to the Korean War, from Suez to the Cuban missile crisis, from Burgess and Maclean to Watergate, Osbert covered the international events of the

age. His particular favourite was the Suez crisis in 1956, which recalled his great cartooning days of the war. Petrol rationing, black marketeers, bungling ministers and disgruntled tommies made, for him, a welcome return to the front page. On the home front he was kept equally busy by sterling crises, power cuts, oil shortages and terrorist acts which came round with increasing frequency. At the height of the 1973 oil crisis, Osbert's mouthpiece, Maudie Littlehampton, complained dryly: 'Some of us have been living in state of emergency, on and off, ever since we left the womb!' The onset of the permissive society was the perfect subject for Osbert's pen. He relished the arrival of trendy vicars, sex education, protesting students, mini-skirts, pot and the pill.

The Countess of Littlehampton, known as Maudie, who became the star of the pocket cartoon, sprang, according to Osbert's biographical note in *The Littlehampton Bequest*, from a long line of baronets. A debutante in the late twenties, she belonged to the glamorous generation of Nancy Mitford and Maureen Guinness. In the 1930s she married her distant cousin Viscount Drayneflete. The wedding at St Margaret's Westminster had taken up six pages of the *Tatler*. The war had been spent working for various undercover organisations 'as well as liaising closely with the free French'. Maudie ended up in Cairo in 1943, 'where her lovely flat on Gezireh quickly became a home from home for all members of White's serving in that theatre.' One of the earliest references to her in a pocket cartoon occurred during 1947 Ascot week. Thereafter, Maudie became a constant presence in Osbert and his readers' lives, renowned nationally for her *aperçus*, put-downs and dry one-liners.

With her finger constantly on the social, political and diplomatic pulse, Maudie thought nothing of interrupting ministers at their desks or cornering diplomats at parties. Days after the invasion of South Korea, a civil servant hands the phone to his minister: 'Lady Littlehampton sends her love and please do you think the Russians will move before Goodwood?' Politically, Maudie was committed to no party. Her liberal candidacy in the 1950 election was easily explained to her husband: 'Willy darling, please don't be cross, but such a pathetic little man came to the door and asked me to stand as a liberal candidate that I said Yes.' Maudie's attraction also rested on her plain speaking. At the announcement of new H-Bomb tests, she is seen turning to a Roman Catholic priest with the words: 'Excuse me, why on earth did you ever give up burning scientists as witches?'

Maudie's fashion sense could not be faulted. On one occasion she even showed off her sexy figure wearing nothing but her coronet, got out for the coronation. 'Oh she is lovely,' exclaimed Nancy Mitford to Osbert,

'Willy, darling, come and see how I am going to look in the Abbey!' (1952)

'Some of us have been living in a State of Emergency, on and off, ever since we left the womb!' (1973, at the time of the three-day week)

'she has become so elegant I long to copy all her clothes – and then of course she is always right about everything.' The fame of Maudie and the Littlehamptons grew to such an extent that in 1973 the innovative young director of the National Portrait Gallery, Roy Strong, even hung their collection of ancestral portraits – in fact, a series of brilliant parodies by Osbert which were accompanied by his learned catalogue in book form, *The Littlehampton Bequest.*

Understandably, many upper class women of Osbert's circle aspired to be the model for Maudie. However, Osbert always insisted that 'she's just a type. Like nearly all of my figures, some people think they can identify themselves, but they're wrong.' Maudie was essential to Osbert's inventiveness as a cartoonist. 'Though she is a figure of upper-class fun,' he told one interviewer, 'Maudie must never be made silly. One wants to keep her as a mouthpiece for what one hopes are worthwhile observations on the times we live in.' His closeness to Maudie was reiterated in an interview with George Melly on the 25th anniversary of the pocket cartoon. 'Like most of us she has grown up. Having started as a slightly dotty class symbol she's been increasingly useful as a voice of straightforward comment, which might be my own.'

Despite his denials, one woman had a reasonable claim to be the prototype for Osbert's muse. She was his wartime love, Pru Wallace. Her striking, angular looks, poise and intelligence are echoed in Maudie. Furthermore she was living with the Lancasters in London in 1946 when Maudie was taking shape in Osbert's imagination. The connection was made by sharp-eyed Anthony Powell, an intimate friend of Osbert who wrote: 'Lady Littlehampton's physical appearance bears a distinct resemblance to her.'

Osbert's daily ritual in producing his pocket cartoons, as numerous colleagues reported, scarcely varied for over forty years. Around four in the afternoon he would turn up at the Art Deco *Express* office in Fleet Street and 'pick his way through the Babylonian splendours of the entrance hall'. On reaching his desk in the general features section in 'a noisy, clattering part of the office, set oddly in the midst of a throng of women writers, he shoots his cuffs, negligently scans the evening papers, reads out, with comments, the society paragraphs that appeal to him, takes a few turns round the office and then, in the middle of feminine chatter and gossip, takes out a drawing pad. In a remarkably short space of time – perhaps half-an-hour – another Pocket Cartoon is ready… .' Osbert's brilliance guaranteed him freedom from editorial interference and from that of the autocratic proprietor, Lord Beaverbrook.

The resulting drawings, executed on sheets 8" x 6", are masterpieces of observation, concision, composition and detail. John Betjeman advised: 'Disregard the joke and just look at the drawings. He can convey facial expressions, the cut of clothes, the material of which the clothes are made, and very often background scenery.' Anthony Powell summed up Osbert's authority as a draughtsman and a cartoonist: 'He's a real original, absolutely himself and no one else. He's got that particular turn for caricature which shows inner knowledge – he knows what it's like from the inside … the most astonishing thing about him is the standard he's kept up with the pocket cartoons over the years. Really there were no pocket cartoons till he invented them. Now they're so commonplace we tend to forget how original the idea was when he began it.'

Osbert had earned his place alongside his great Charterhouse peers, Thackeray, Leech and Beerbohm. He could have been describing himself when he wrote in a review: 'the English are a nation of illustrators… For us 'art for art's sake,' 'significant form' etc. are far less potent and productive slogans than 'every picture tells a story'; all our best artists, or nearly all (Rowlandson, Hogarth and frequently Sickert) are raconteurs.'

Osbert's productivity was constant. Not content with the demands of Fleet Street and the stage, he was much in demand as an illustrator of books and book jackets, working for a variety of authors from P. G. Wodehouse to his old friends Nancy Mitford and Anthony Powell. Books and articles still flowed from his own pen. He produced two volumes of memoirs, a collection of light verse, a gazetteer of Byzantine churches and in *Here of All Places* a combined, revised edition of his architectural classics *From Pillar to Post* and *Homes Sweet Homes* with some American examples added. Every year or so, a collection of pocket cartoons was issued for the Christmas market. Imbued with the Victorian work ethic of the Lancasters, which, true to the family code, remained uncorrupted by his private wealth, Osbert never let up. As his daughter, Cara recalled: 'he was always in the studio – working, working'.

Despite his many other activities he constantly campaigned for the preservation of historic buildings, particularly in London. He had been one of the first conservation activists before the war when he had played a leading part in the fight to save Abingdon Street, a pleasing Georgian row, since demolished, in Westminster. In the decades of destruction after the war, he served as an adviser for over twenty years on the GLC Historic Buildings Board and waged ceaseless campaigns, often in the letters page of *The Times*, against developers and brutalist architects. A particular hate figure was Basil Spence whom he taunted for his barbaric Home Office

Artwork for the jacket of *Much Obliged Jeeves*. Osbert wrote: 'all right minded people should split their sides over the major works of Mr P.G.Wodehouse.'

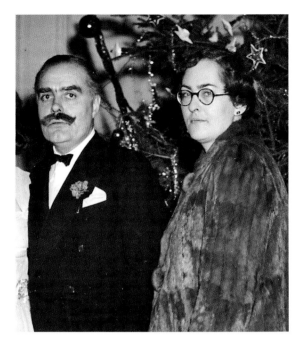

Osbert with Karen (left), and with Anne (right).

building in Queen Anne's Gate. When Spence protested that it would be all but concealed by trees, Osbert enquired in *The Times*: 'if any architect in recorded history… engaged on an important public building on a prominent site, has ever put forward before the claim (one hopes justified) made by Sir Basil Spence… that his masterpiece will, when finished, be to all intents and purposes invisible?' Osbert carried on his attrition against architectural philistines in his books, casting the husband of Maudie's second daughter, who appears in a portrait by David Hockney in *The Littlehampton Bequest*, as a ruthless speculator.

Changes had taken place in the post-war Lancaster household. In 1953 the family moved from London to a large Victorian villa, Leicester House, in Henley-on-Thames. John Craxton loved the whole set up, 'Osbert made the garden with statues from Italy – it was absolutely heavenly.' However their near neighbour, John Piper, described it as 'so like London you would never know you were in the country.' Even so, Osbert swiftly tired of commuting and found himself a small utilitarian flat in Chelsea where he spent the week. This split life accentuated the inherent difference between Osbert and Karen, which the great diarist James Lees-Milne defined after seeing them during the war: 'I admire her total indifference to the world's opinion. Whereas Osbert is incorrigibly social, she is a natural recluse.' At other levels the couple grew closer, brought together by Karen's involvement in his work for the theatre. Her skill as a craftsman led her to become his model-maker and adviser on costume design.

Although not a womaniser, Osbert liked women and loved their company; he had one or two relationships with women, who moved in his worlds of literature and the arts. These infidelities caused him, like his friend John

'That's St Paul's, that was!' (24 July 1969)

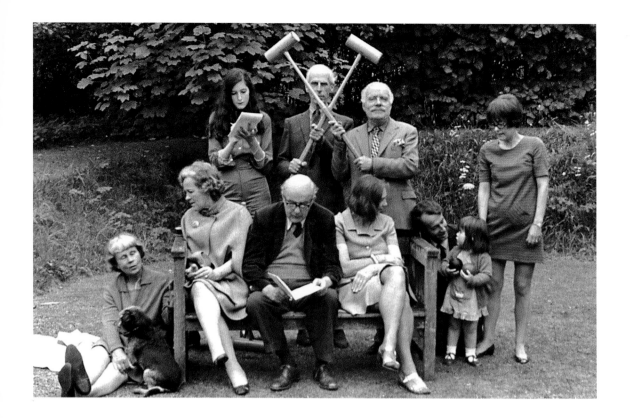

Aldworth 1967. Back row (from left): Clare Hastings, John Piper, Osbert, Cara. Front row: Penelope Betjeman (on grass), Diana Murray, John Betjeman, Myfanwy Piper, Frank Tait, Louisa (aged 2) Cara's daughter. Photograph taken by Jock Murray.

Betjeman who was often in a similar situation, agonies of guilt. But moral torment, he believed, was the price one had to pay. Once, Cara who attended a very high-church school, raised the possibility of her going to confession. 'I always think dear, that's rather self-indulgent.' Osbert had responded.

Karen had suffered from serious diabetes all her life. Even so, her early death in 1964, at the age of fifty, came as a brutal shock. Osbert was shattered. He wrote to his friend Patrick Balfour: 'You are so right about Karen – so almost comically intolerant in small things, in everything that really mattered so infinitely understanding and forgiving. In thirty years many a cross word but never a failure of love or sympathy. Her capacity for making allowances was never exhausted and deeply grateful for it I had cause to be.' Following her death, Osbert lost all interest in the house in Henley and sold it. He moved back to London full time buying an apartment on three floors at 12 Eaton Square.

Osbert now sought the companionship of one of his closest female friends, Anne Scott-James, whom he had known in Fleet Street since before the war. One of the pioneering women's editors and journalists, Anne had made her name working for titles such as *Vogue*, *Picture Post* and *Harper's Bazaar*. By the 1950s she was working for the *Sunday Express* and used to bump into Osbert in the office or the Fleet Street wine bar, El Vino's. Osbert had also produced illustrative work in the late forties for the *Strand Magazine*, which was edited by her then husband Macdonald Hastings. Initially, Anne found Osbert a little too 'stagey', but her perception changed

over an impromptu dinner at the Ritz, following a dreary *Express* drinks party. From then on, their friendship deepened at the realisation of a shared world in common.

Osbert spent an increasing amount of time with Anne after Karen's death. The intensity of his feelings became clear after he pursued her to Paris where she was staying with her friend, the novelist Romain Gary. 'There was a hammering on the front door,' Anne recalled, 'Romain fell back in surprise, exclaiming: "Osbert's here!" ' ' Not only was the Frenchman taken aback by such an uncharacteristic lack of *sang froid*, but so was Anne. 'He was in a state of shock', she went on, 'it was a big surprise to me for him to do anything so dramatic or emotional.' In 1967 they were married. The event was hailed by the *Daily Express* as 'a wedding of rare Fleet Street talents.'

The Lancasters set up home in 12 Eaton Square with Clare, aged thirteen, Anne's daughter by her first marriage. Step-father and daughter hit it off from the start. 'We shared a lot of jokes,' Clare recalled. 'He was brilliant; I ganged up with him against my mother. She was bossy, but he liked that. They got on. I can't imagine a better step-father.' By contrast, Osbert's relationship with his own children William and Cara, which had been disrupted by their evacuation to America, followed by boarding school, had always been more distant. Cara, who later became extremely close to her father, explained his attitude: 'that was his class and generation'.

Osbert's working life continued its uninterrupted course. Each day began in the beautiful first floor drawing room in Eaton Square where, robed in an exotic dressing-gown, one of a number acquired in the Middle East, he would write or draw all morning. A great deal of huffing accompanied the process of writing whereas the process of drawing produced, according to Anne, 'a beatific smile on his Roman Emperor's face.'

Although photogenic, Osbert was in later life noted for his craggy looks and outsized head. But the power of his personality transformed these features. Jock Murray's wife Diana described him as 'very striking – *farouche*.' A colleague on the *Express*, Anthony Hern, remarked: 'His head, poised above a strongly striped collar, has a curious dignity: large eyes reflect an inner amusement, and outwardly miss nothing; a well-tended neo-Edwardian moustache goes well with a habit of shooting his cuffs.' John Betjeman was transfixed by his eyes: 'When he suddenly stops talking', he wrote, 'and his enormous blue eyes open a little larger, I know that he has registered something that will either come out as a funny story or a cartoon.'

Osbert's fame as a dandy attracted the lenses of some of the greatest photographers of the day including Cartier Bresson, Cecil Beaton, Lee Miller and Lord Snowdo n. His dress sense was inspired by his

Osbert the dandy, by Adrian Daintry.

grandfather's generation. 'Most people', he explained in an interview, 'are fascinated by the period which lies just beyond their memory, and such glittering survivors of *la Belle Epoque* as came my way when young, left a deep impression.' He retained that period's love of accessories such as canes, hats and buttonholes. But like all great dandies, Osbert made innovations of his own. He claimed to have started the revival of the smoking jacket with quilted lapels and was one of the earliest to adopt the white dinner jacket. His hallmark pink shirts were first worn at Oxford. High on his list of sartorial hates was 'The Man in the Grey Flannel Suit'. For him it represented the lack of individualism of the modern age. Osbert was never afraid of dressing to extremes. On one occasion, he picked Cara up from school dressed for a holiday in France. He was wearing co-respondent shoes, a blue linen jacket with horn buttons, a pink shirt and a yellow bow tie.

Beneath the eye-catching façade lurked a surprisingly unassuming soul. 'He was a very modest man,' Anne Lancaster recalls, 'very objective – often referring to his humble talent. He hated being asked about his private feelings, loved being asked about his work.' His most intimate friends – John Betjeman, John Piper and Jock Murray – were all entwined in his creative world. As John Craxton said: 'Osbert was more connected with what he did than with what he was.' This may have made him self-centred, but it was his being. Diana Murray speaks of his well-bred approach to life, a sign of his self-confidence as a man and an artist. 'The great thing about Osbert,' she states, 'is that he never pushed what he could do, never ever boasted, just got on with his life's work.'

By the end of his career, Osbert had become a national institution. He was lauded with academic honours – not least from Oxford – and in 1975 received a knighthood. He still maintained his daily routine, leaving home at lunch time immaculately dressed for one his beloved London clubs, before making his way to Fleet Street. Then, in 1978, Osbert suffered the first of a serie of strokes. His condition was sufficiently serious for Douglas Orgill, his colleague at the *Express,* to jot down a vivid portrait of him at work for use in an obituary. 'When Osbert arrived puffing and pottering through the long editorial passages, there came with him an echo of an earlier age… the dark suit, the flower in the lapel, the Edwardian moustaches a-quiver, eyes glinting with gleeful mischief. The usual atmosphere of contrived crisis surrounded him: "… not a taxi cab in sight between Park Lane and Piccadilly. I assure you… monstrous… monstrous." His redoubtable and long suffering secretary Mrs Liz Gregory had the evening newspapers ready for him. Pencil in hand, he sat and went

through them with infinite care, chuckling, clucking, sighing. At last, he would begin to draw.' Let the curtain come down on Osbert at work on his next incomparable cartoon.

He died on 27 July 1986, after eight years of painful decline, and was buried with his Lancaster forebears in the churchyard of East Winch in Norfolk.

Osbert in 1976
(photo: Fay Godwin)

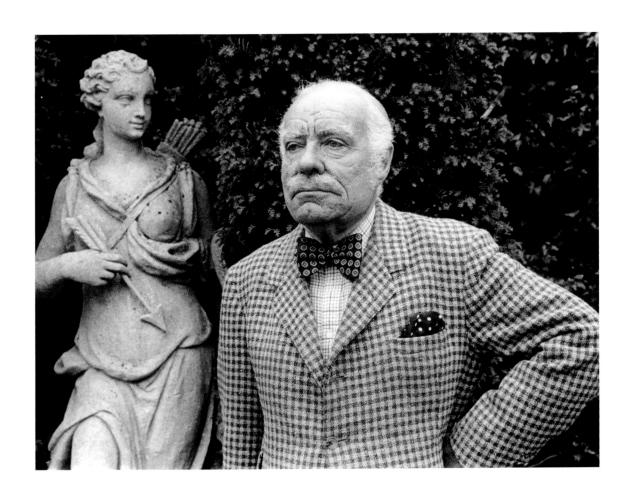

"Summa is icumen in"

Uffington 1935.

FRIENDS

A musical evening laid on for the Uffington Women's Institute in 1935 by Penelope Betjeman. At the piano: Lord Berners; back row: Adrian Bishop, Karen Lancaster and Osbert on the flute, Penelope, seated, playing 'a strange instrument resembling a zither'; standing at the front, Maurice Bowra and John Betjeman. They are performing 'Sumer is icumen in'. Osbert wrote: 'I cannot now recall in all the years that have since elapsed, ever having spent an evening of such continuous and unalloyed pleasure.'

Osbert's childhood and schooldays threw up few lasting friendships. His most dashing acquaintance at Charterhouse was Barbara Cartland's brother Ronnie, a dandy who stood for all that was modish in the world beyond the windswept cloisters of the school. Socially, Osbert found his feet at Oxford where he was a leading light in university drama and journalism. Dandies and aesthetes were at the heart of his circle, which numbered the poets John Betjeman and Louis MacNeice, Dada-ist Tom Driberg and the future conservationist and diarist James Lees-Milne. An earlier generation of undergraduates, many encountered at the salon of the don Maurice Bowra also swam into his ken. These included the novelists Evelyn Waugh and Anthony Powell, the travel writer Robert Byron, art historian Kenneth Clark, and High Priest of twenties' aestheticism Harold Acton. In general, this rich crop of talented bohemians was to form the nucleus of Osbert's future world. Two key additions were added post-Oxford, his publisher Jock Murray and the artist John Piper.

Osbert's wartime posting to Greece expanded his social horizons. Political figures such as Harold Macmillan went on to become influential acquaintances and his contacts made at the higher reaches of the Foreign Office secured, on later travels, a welcome at embassies across the globe.

He proved to be a good and courteous friend. Harold Nicolson, who served briefly as his boss during the war, was touched to be given lunch by him after he was sacked. His colleagues on the *Express* adored him.

At the peak of his fame, Osbert was the ultimate man about town. His daily routine involved lunching at one of his numerous clubs, sauntering into the *Daily Express* to draw his cartoon surrounded by a bevy of feature writers and secretaries, and then progressing to a private view, first night or livery dinner, or more often descending on Jock Murray at 50 Albemarle Street to gossip late into the night or correct the proofs of his latest book. He knew everybody and everybody claimed to know him. 'He was frightfully good humoured,' his wife Anne recalled, 'he had a tremendous enjoyment of life, adored parties and city dinners. Whenever he entered a room, people would say "Osbert come here", he would just abandon me!'

One of Osbert's favourite books was Thackeray's *Vanity Fair*. Like Thackeray, another Old Carthusian, he loved the spectacle of Society, not for its own sake, but as inspiration for his art. As the painter, John Craxton wrote: 'Osbert was more connected with what he did than what he was.' His three most intimate friends – John Betjeman, Jock Murray and John Piper – were all entwined in his creative world. The rest of life was pure theatre.

'Mr John Betjeman awaiting inspiration and the 4.47 from Didcot'. *The Strand Magazine*, March 1947. First met at Oxford, Betjeman became one of Osbert's closest friends, sharing the same love of architecture and Anglicanism, and the same sense of both guilt and of humour.

'Freya Stark explaining to a relatively unsophisticated audience the genius of Mr Norman Hartnell.' *The Strand Magazine*, 1947. Osbert was a great fan of the indomitable travel writer Freya Stark, admiring her keen eye for architecture.

Benjamin Britten, *The Strand Magazine*, February 1947. Osbert later got to know Britten well through designing an opera by Poulenc, performed at the Aldeborough festival, and a production of *Peter Grimes* for the Bulgarian National Opera.

'Mr John Piper enjoys his usual ill luck with the weather'. *The Strand Magazine*, 1947. Osbert and Piper became fast friends at the beginning of the war.

A great admirer of his work, Osbert rated him 'one of the very few completely satisfactory English artists working today'. They collaborated on designs for the Festival of Britain in 1951 and Piper was responsible for Osbert getting his first commission as a theatrical designer.

"I mentioned that at one time I had been intended for the Diplomatic Service and that I had always regarded it since with some of the wistfulness he felt for literature.
C. C. Sunday Times.
28. 9. 52.

opposite: 1920s Oxford – Colonel Kolkhorst's Sunday morning reception in Beaumont Street. Top left window (left to right): John Betjeman in profile, Brian Howard and Dennis Kincaid; top right window: Colonel Kolkhorst with black jacket; street level: Louis McNeice (with scarf) and Hugh Gaitskell. The disapproving landlady is looking over the curtain. The 'Colonel' held a nineties salon every Sunday to which the smarter Oxford aesthetes flocked.

above: Literateur and *bon viveur*, Cyril Connolly was an old acquaintance from Oxford, and somewhat of a joke figure in Osbert's immediate circle. Osbert contributed illustrations to 'Cyril's intellectual monthly', *Horizon*, during the war and habitually sent the novelist Anthony Powell caricatures of the rotund figure. After Connolly got wind of the drawings, relations grew strained but were patched up over a drink at White's Club. 'I implore you', wrote Osbert to Powell of the drawings, 'to, if not destroy, at least conceal all the indecent ones, if the sage should be unexpectedly in your neighbourhood.'

IN MEMORIAM. G.S.

His Excellency, accompanied by his Muse, presents his credentials. London 1957.

above: The poet George Seferis presenting his credentials on becoming Greek Ambassador. Published in the *Cornhill Magazine* on his death in 1971. Seferis became a close friend of Osbert in Athens at the end of the war. Others who formed his Athenian circle included the writer Patrick Leigh Fermor, painters John Craxton and Nikos Ghika, and the writer George Katsimbalis, 'the Colossus of Maroussi'.

opposite: In the early 1930s, Osbert became an *habitué* of the Café Royal set made up of writers, artists and journalists who gathered on Thursday nights. Some members feature in this illustration. Balcony (left to right): Tom Driberg, Cyril Connolly, Brian Howard. Included in the main drawing are Evelyn Waugh, Cecil Beaton, Jack Beddington, Kenneth Clark, Kingsley Martin, James Agate and Peter Quennell. 'On almost any night', Osbert wrote, 'one could be certain of finding friends or acquaintances from Oxford, the Slade or Fleet Street.'

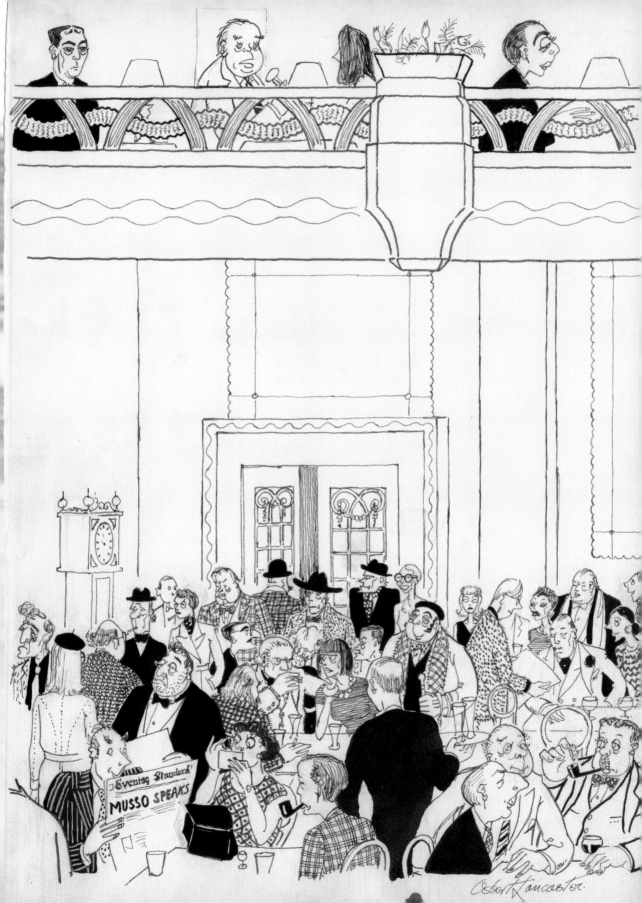

Evening Standard
MUSSO SPEAKS

TRAVEL

Osbert first travelled abroad in 1920 with his mother to visit his father's grave in the still battle-scarred plain at Arras. From the moment the Channel packet docked at Boulogne and the bloused porters rushed on 'in a cloud of garlic and ferocious high spirits', Osbert found everything about abroad 'utterly and fascinatingly unfamiliar'. For most of the trip, which included a visit to Paris and the chateaux of the Loire, he was in a state of euphoria. His passionate love of travel had been born.

During his teenage years, cultural trips abroad with his mother became an annual event. Oxford vacations offered further opportunities to spread his wings and travel fourth class across Europe in the fashionable quest of baroque architecture. One last dash across the Channel occurred in August 1939 for a church crawl in Normandy.

Osbert's wartime posting to Athens saw his transformation, under the most dangerous of circumstances, from pre-war cultivated tourist into a clear-eyed travel writer. Within weeks of his arrival, Osbert was reporting back to his publisher Jock Murray: 'I fully intend a little work on Greece and have already filled one note book full of drawings'. The result was *Classical Landscape with Figures*, published in 1947, an unflinching but also lyrical account of the condition of post-war Greece.

After the war, scarcely a year passed without a return to the country (an exception was made during the dictatorship of the Colonels), but Osbert also found time to travel widely elsewhere, including Egypt, the Sudan, Iran and Beirut, often with his close friend the travel writer Alan Moorehead and his wife Lucy.

Many journeys were professional assignments. He had to oversee his designs for Britten's opera, *Peter Grimes*, in Sofia, research his gazetteer of Orthodox churches, *Sailing to Byzantium,* in Turkey and the Balkans, and carry out numerous commissions for articles and book illustrations. Whether travelling for pleasure or work, he was never without a large green-bound sketchbook which often also served as a travel diary. His second wife Anne describes how 'he loved drawing' and 'he hated holidays if he couldn't draw, he regarded drawing as supreme.'

A great admirer of the picturesque tradition of English landscape painting, he wrote to Jock Murray of Attica: 'The views, and you know what a "pushover" I am for the *wunderschönes* Panorama, are really extraordinary.' But it was not just the set-piece backdrop that caught his eye. Every aspect of the foreign scene, however humble, inspired him.

Osbert sketching in Greece, late 1940s

Jacket artwork for *Classical Landscape with Figures*, Osbert's travel book on Greece, published in 1947. His wartime posting to Athens began a life-long love of Greece. 'I had always been secretly rather proud of the book', he wrote to John Betjeman, 'feeling that for once one might have communicated something of the emotion that the country had inspired on first acquaintance and the strength of one's feelings.'

clockwise from top:
Talking heads ('the Greeks are, of all nations, the most gregarious'); kiosk (the diversity of the Greek press); seated figures (the 'form' of Greek politicians is assessed with the same intensity as the British rate racehorses and greyhounds); 'burly toughs', dancing with 'tireless agility and grace', in a Piraean brothel; orthodox 'pappas', monks and nuns; an Arcadian shepherd in fustinella and homewoven lambskin coat.

top: High, two-wheeled cart on the Argolid plain, decorated like a coster-monger's barrow and pulled by the local breed of horse.

above: On the road to the eleventh-century monastery of Osios Loukas in Boeotia.

SAILING TO BYZANTIUM

AN ARCHITECTURAL COMPANION

OSBERT LANCASTER

Jacket artwork for *Sailing to Byzantium*, 1969. This is a gazetteer of Byzantine architecture written for 'occasional church-crawlers', which encompassed Italy, Greece, Bulgaria and Turkey. Osbert acknowledged the influence of the pre-war travel writer and Byzantinist Robert Byron for kindling his own passionate interest in Byzantine architecture. 'He succeeded in giving form and substance to what had hitherto been nebulous and vague.'

top: The port on the island of Hydra in the Saronic Gulf, revealing the church of the Monastery of the Panaghia which dates from the seventeenth-century. Osbert's sharp eye for decorative detail spotted hanging in the interior 'a large candelabra in gilded bronze decorated with fleur-de-lis looted from the Tuileries in 1792.' Hydra is much reduced since its great days as a port in the nineteenth-century and Osbert recorded that only in the summer months does the town display 'a certain trendy animation.'

above: Osbert, accompanied by the elegant figure of his wife Anne, being led to a remote church by the priest.

previous spread: High winds on Tenos in 1961 'with the usual regiment of empty chairs outside the café'.

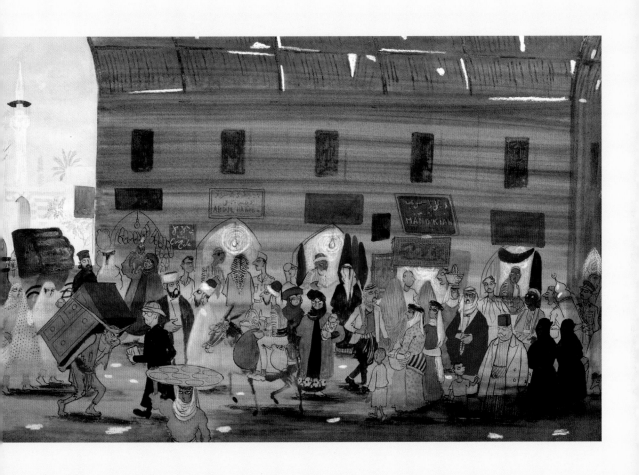

Entry to the Souk, Tunis, April 1961. It was drawn on a return visit to the country. '. . . the souk is happily unchanged save for a new section devoted to the sale of transistor radios . . . the usual tourist junk, but the standard of carpets rather improved'. This picture was exhibited at one of his regular shows in West End galleries of topographical paintings and other work.

following spread: Group of Nubian women and children, the Upper Nile. In November 1960, Osbert journeyed down the Nile, keeping an illustrated travel diary. 'For most of the time villages are inhabited entirely by women and children as all the men go to work in lower Egypt.' Behind is the fortress if Ibrim, refortified by the Mamelukes.

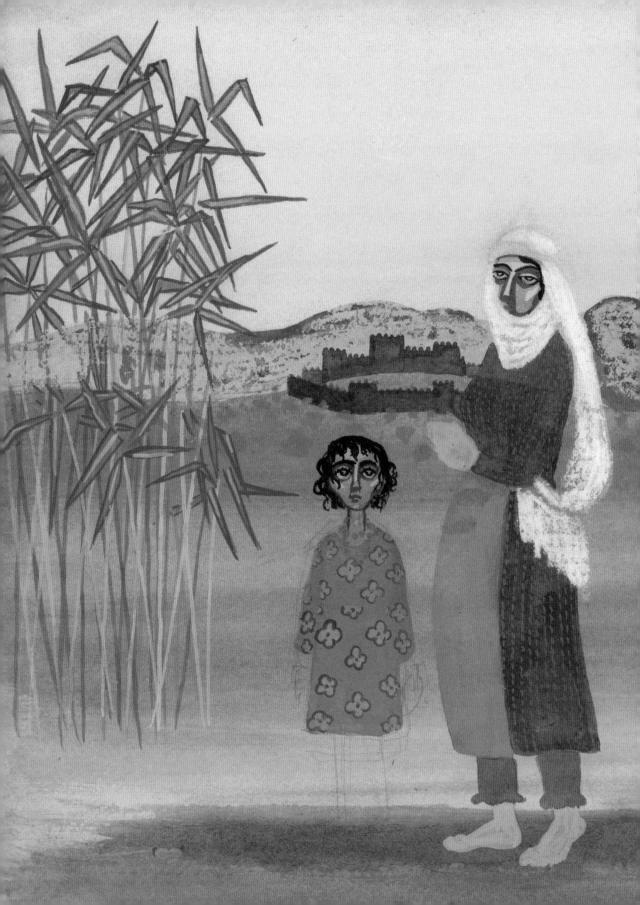

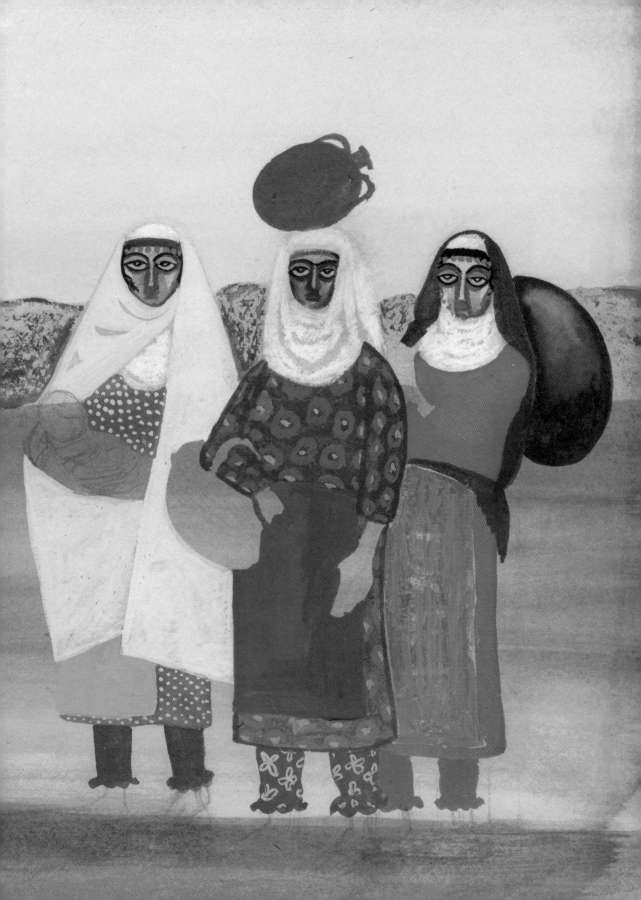

A do-it-yourself WC arrives
in Egypt. Osbert travelled in
Egypt, the Sudan,Beirut and
Iran as well as Greece.

top: An Arab village south of the Aswam dam. He found them, scruffier than the neighbouring Nubian villages. All were to be flooded. 'Tragic to think that the whole area will be an enormous lake when the bloody high dam gets going.'

above: The Colossi of Memnon, 22 November 1922. At Luxor the previous day, Osbert had been unimpressed by the Valley of the Kings. He looked at the monuments through uncompromising western eyes: 'Saw three tombs each duller than the last. Same old themes on the walls. Did the ancient Egyptians never feel the urge to experiment?'

opposite: Souk in Tunis, April 1961. 'The population struck me as being more westernized … the number of veiled or semi-veiled women still considerable however.'

top: A panoramic view of Jerusalem showing Osbert's watercolour technique of first covering the drawing with a wash of yellow ochre. This was the lesson taught by his art master, 'Purple' Johnson, at Charterhouse. This 'simple accomplishment,' Osbert acknowledged, 'has proved unfailingly useful'.

above: Greek village. Osbert has identified the colours as did Edward Lear, of whom he was a great admirer.

MONSIEUR PHILLIBERT HABITE UNE JOLIE MAISON DE CAMPAGNE,
CONSTRUITE DE BRIQUES JAUNES, SUR UNE MAGNIFIQUE TERRASSE
ORNÉE D'UN AVEC UNE BALUSTRADE ORNÉE DES VASES RÉMPLIES
 SERRÉ
DES GÉRANIUMS. IL Y A UNE CONSERVATOIRE OÙ ON TROUVE DES
PALMIERS ET SUR LE TOIT ON APERÇOIT DES PIGEONS BLANCS.
SUR LA TERRASSE ON REMARQUE 'THÉRÈSE' UNE ÉNORME CHATTE
NOIRE ET

Voici Monsieur Phillibert. C'est un monsieur français
très fort, riche avec des grandes moustaches noires
des lunettes
et des jolis petits favoris
avec lui on voit son chien 'Loulou'

En été il porte
un chapeau de paille
une cravate bleue
un veston blanc
des pantalons gris perlés un parapluie
des chaussures blanches
une boutonnière et une
canne

En hiver il porte
un surtout vert
avec des poches énormes et
un collet de fourrure,
un chapeau melon
des bottes.
Loulou porte une jolie
jaquette à carreaux

France was the first foreign country Osbert ever visited. The trip with his mother in 1920 left him a committed Francophile. Every year he stayed with a highly cultivated Belgian family in the south of France where he learnt fluent French with a Belgian accent. Here he provides a French lesson.

opposite: He describes Monsieur Phillibert's house. *'Monsieur Phillibert habite une jolie maison de compagne…'*

above: He tells us about Monsieur Phillibert and what he wears in the winter and summer. *'Voici Monsieur Phillibert. C'est un monsieur Français, fort riche avec des grandes moustaches noires…'*

Sketches from his memoir *All Done from Memory*, published in 1967, recording sights on his first trip to France in 1920 'every detail of which remains strangely vivid'.

top: Travelling by train across Picardy and Artois – 'the fleeting sight of a priest in soutane and shovel hat'.

above left: 'My first sight of a genuine old-fashioned, *bien pensant,* French general.'

above right: 'The first Frenchman I had ever conciously seen at close quarters was the gentleman of whom my mother enquired the whereabouts of the local train to Arras.'

In 1949 Osbert made his first visit to the United States, sending back cartoons to the *Daily Express* depicting Maudie and Willy Littlehampton's first impressions of the country. Osbert reported back his own experiences to Jock Murray: 'I have seen… the Museum of Modern Art, President Roosevelt's grave and the bottoms of heaven knows how many upturned glasses.'

left: (on Gladstone hotel writing paper) 'I'm beginning to wonder, Maudie, whether or not my subscription to the English-Speaking Union is really fully justified'.

right: (on Cunard White Star writing paper) 'In England, Mr Flackenbaker, we regard winning the game as rather less important than the spirit in which it is played.'

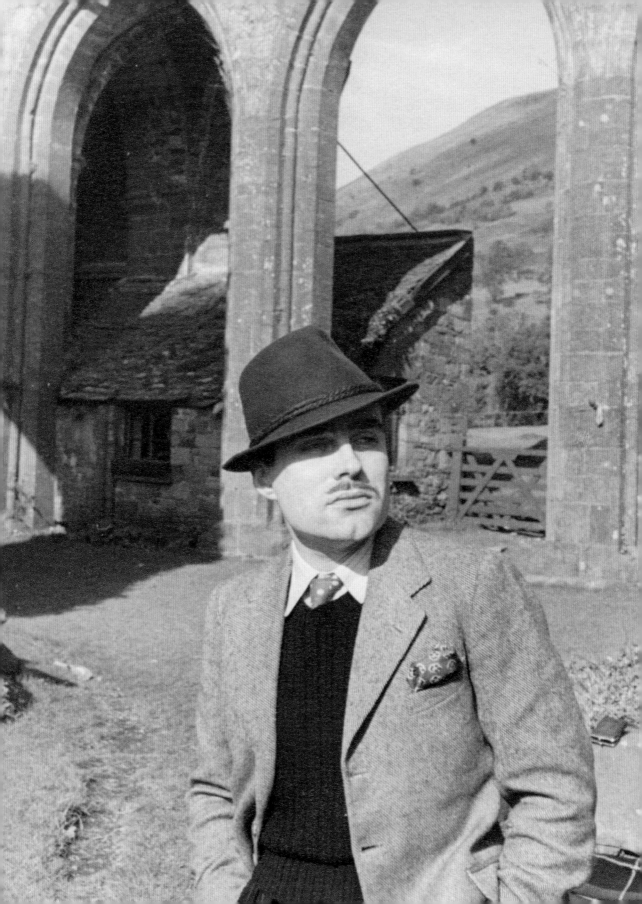

ARCHITECTURE

Even as a child, Osbert was 'period-besotted', absorbing every detail of the crammed Victorian interiors that served as the backdrop to his life before the First World War. As Tom Driberg remarked: 'He must always have had a note-taking eye and a keen interest in the architectural setting of his life and art.' This instinct was nurtured by his mother who took him on cultural trips abroad to widen his knowledge of European art and architecture. His first sight of St Mark's Square with its 'staggering' view of S. Giorgio Maggiore was, he recalled, one of the 'great moments of revelation of my childhood'.

His architectural education was continued at university under the tutelage of his close friend, John Betjeman, who took him on church crawls round Oxford. Vacations were spent travelling in Central Europe 'sharing to the full the contemporary passion for the baroque'. After Oxford, he landed a job on the highly influential *Architectural Review*, which launched his career as an architectural satirist. His first book, *Progress at Pelvis Bay*, lampooned the greed and philistinism of District Councils which were responsible for the mutilation, both actual and threatened, under way in cities and towns across England.

Osbert in the 1930s at Llanthony Abbey in Wales, close to where the sculptor and typographer, Eric Gill, lived and worked. Jock Murray, his publisher and a friend of Gill, had invited him to stay. They slept 'in the north tower of the ruined west front ... in vast feather beds.' Architectural expeditions were made to local towns such as Abergavenny. Osbert reported back on their finds to John Betjeman: one included a very un-English eighteenth-century house 'built on to a heavily restored Early English Priory Church'.

Osbert went on to write a series of architectural polemics in the guise of disarming 'picture-books', which set out to open the eyes of the general public to the buildings around them. Only then, he argued, would 'the present lamentable state of English architecture' be improved. Most influential was *Pillar to Post*, published in 1938, an historical survey of British architecture which satirised the constant revivalism of styles at the expense of new forms of expression. The writer and politician Harold Nicolson identified Osbert's true intent: 'Under that silken sardonic smile', he wrote, 'there lies the seal of an ardent reformer.'

Modernism appeared one answer to the stylistic impasse. However, Osbert revised his opinion after the war, concluding that 'Functionalism has been exalted into a dogma so that now nothing is ever left to our imagination.' One of the first members of the Georgian Group, he campaigned ceaselessly, particularly in London, for the preservation of historic buildings and to check the ambitions of 'speculative builders, borough surveyors, government departments and other notorious predators'.

In 1949, Osbert published *Drayneflete Revealed*, an architectural satire composed as a pedantic local history charting the 'improvements' imposed on the town of Drayneflete over the centuries.

He also illustrated the impact of development on the once charming crossroads, known as Poet's Corner, a mile out of the town. The first house was a gothic lodge built by Lord Littlehampton on the edge of

his park for the poet Jeremy Tipple. This survives although its surroundings are transformed from rural idyll to industrial suburb as we see in the following drawings.

Poets' Corner 1800

Poets' Corner 1830

Poets' Corner 1860

Poets' Corner 1890

Poets' Corner 1925

Poets' Corner 1949

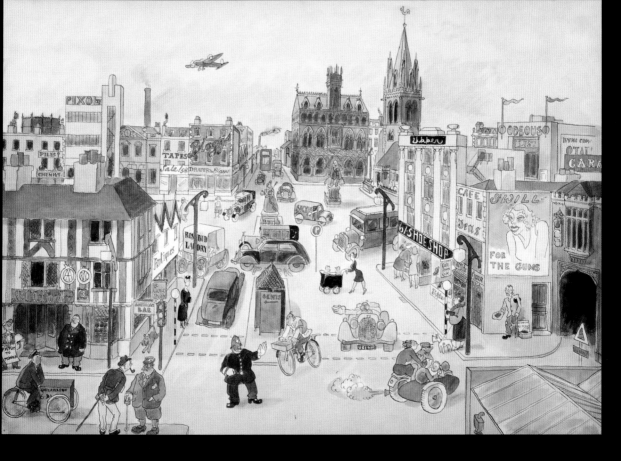

Drayneflete in the early 20th century

Changes wrought on the centre of Drayneflete; one of the few surviving ancient buildings is the medieval Gateway of the house of Augustinian Canons. The statue of Prior Bloodwort in the niche has been replaced with traffic lights. Other changes include the demolition of the 17th century town hall to make way for a Victorian gothic example of 1881 designed by Sir Giles Clerestory. Likewise the parish church was restored to its original 'pristine beauty' by Sir Gilbert Scott in the 1870s and the equestrian statue of William of Orange displaced by Queen Victoria. The 20th century saw the handsome 18th century Corn Exchange truncated by Pixol's showrooms and The King's Head Hotel undergo half timbering. An anonymous critic in the *Observer* assessed the impact of *Drayneflete Revealed*: 'Before Lancaster none had so graphically showed the inhabitants of these distressing places just what kind of a visual chamber of horrors they had allowed to flourish around them.'

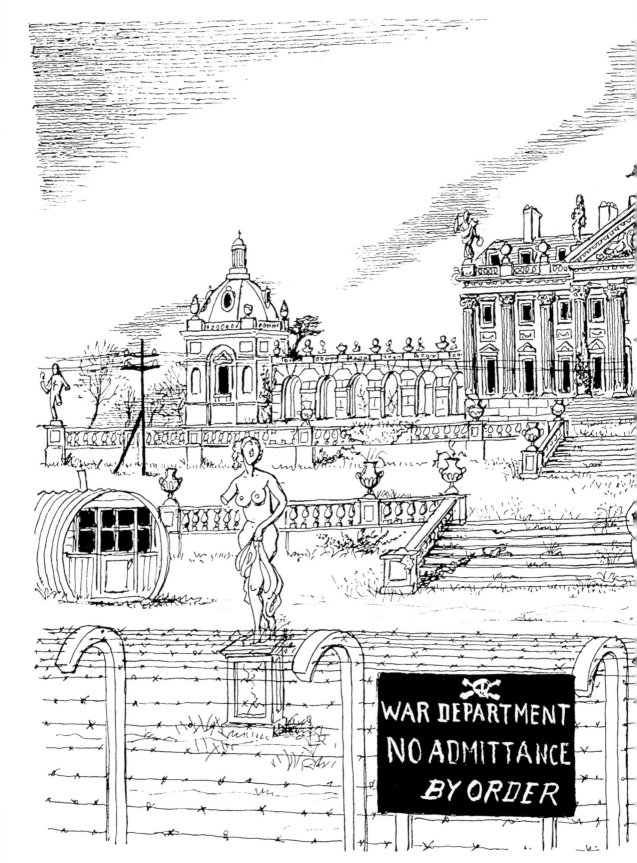

WAR DEPARTMENT
NO ADMITTANCE
BY ORDER

Great houses of fiction

Osbert contributed a series of drawings to the exhibition, 'The Destruction of the Country House', staged in 1974 at the Victoria & Albert Museum. His theme was the fate of houses that had survived the ball and chain but remained blighted by development or institutional use. His examples, based on the great houses from fiction, remain pertinent today and are still cited by Marcus Binney, co-curator of the exhibition, as warnings to conservation groups. Marcus Binney commissioned the series from Osbert over drinks at the Garrick Club. 'He downed three dry martinis in quick succession without talking about the project at all,' Binney recalls, 'and got up to leave with the words, "Don't worry, I know exactly what to do." And he did.'

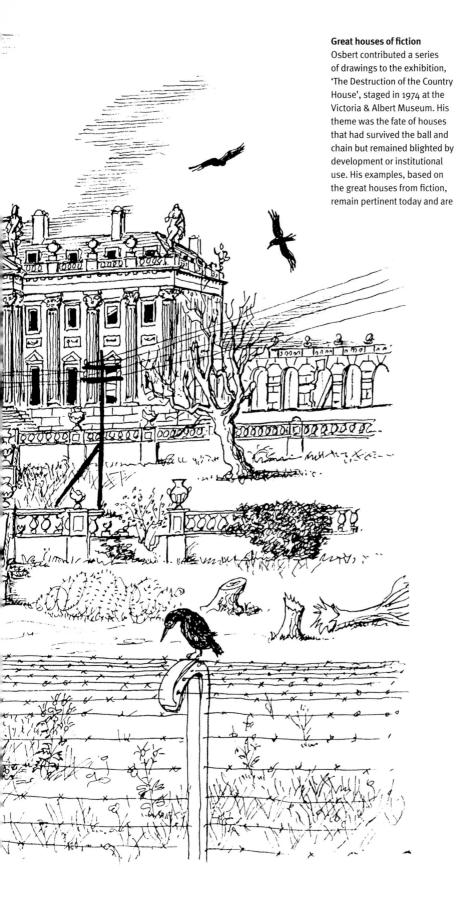

Brentham from *Lothair* by Benjamin Disraeli who wrote: 'it would be difficult to find a fairer scene than Brentham offered in the lustrous effulgence of a glorious English summer.'

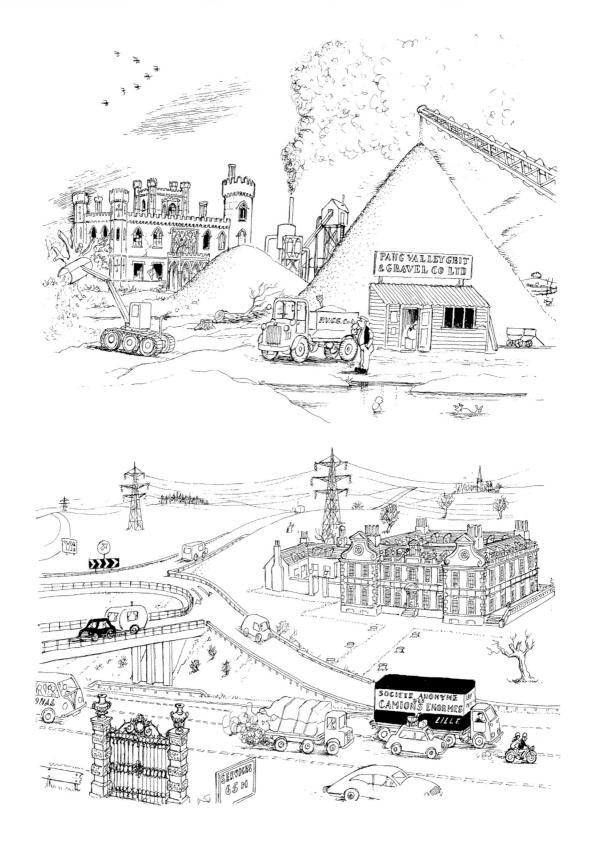

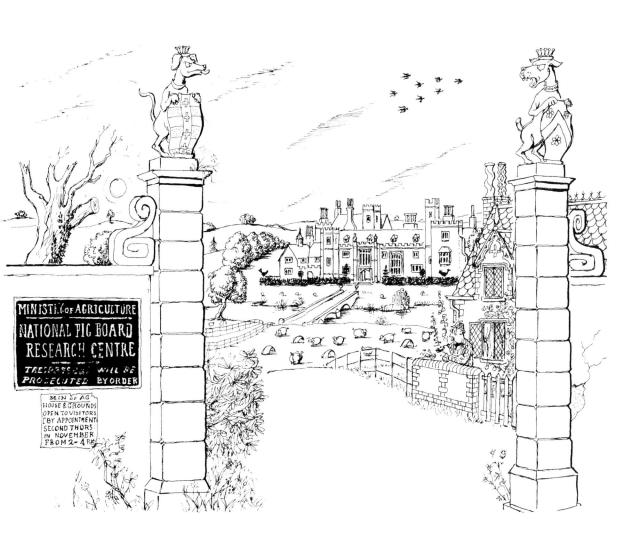

Within the illustration:

MINISTRY of AGRICULTURE
NATIONAL PIG BOARD
RESEARCH CENTRE
TRESPASSERS WILL BE
PROSECUTED BY ORDER

MIN OF AG
HOUSE & GROUNDS
OPEN TO VISITORS
[BY APPOINTMENT]
SECOND THURS
IN NOVEMBER
FROM 2-4 PS

Chesney Wold (opposite bottom) from *Bleak House* by Charles Dickens. Osbert explained that the house had fallen into the hands of a speculator in 1946 and then fell prey to the Minister of Transport at the time of the construction of the M21.

Crotchet Castle (opposite top) from the novel by Thomas Love Peacock who set the house 'in one of those beautiful vallies [sic] through which the Thames rolls a clear flood amid flowery meadows... '

Blandings Castle (above) from the Jeeves novels by P.G.Wodehouse. Owing to economic circumstances Lord Emsworth, the noted pig breeder, recently handed over his ancestral home to the government's Pig Board Research Centre in exchange for a lease of a lodge-keeper's cottage. The interior has been converted to the purposes of bureaucracy.

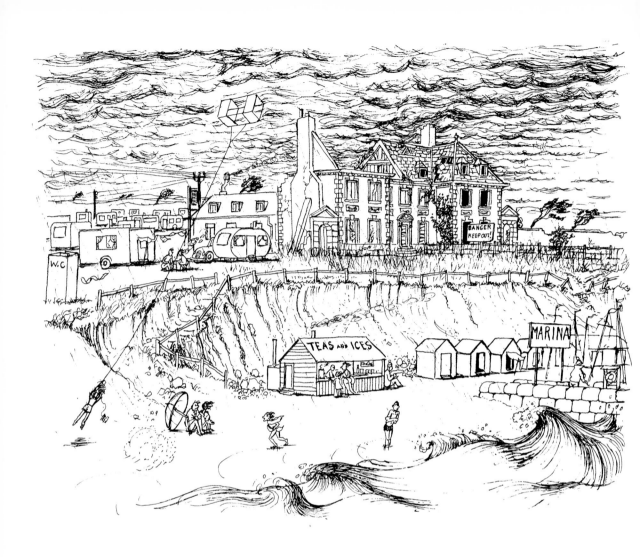

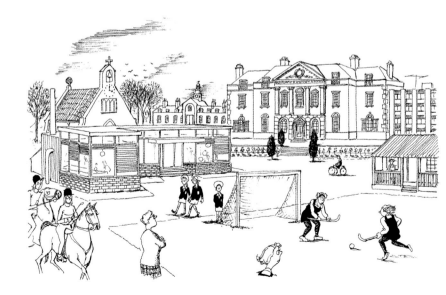

Locksley Hall (above) from the poem by Alfred Lord Tennyson. Abandoned due to erosion, the hall fell into the hands of a farmer who let the garden as a caravan park. The house has been abandoned to its fate.

Mansfield Park (right) from the novel by Jane Austen. The house, by Wyatt, became a girl's school before 1914. Many additions have sprung up, including a wing by Sir Basil Spence; no 'unconvincing pastiche' but 'a forthright and welcome expression of twentieth-century ideals'.

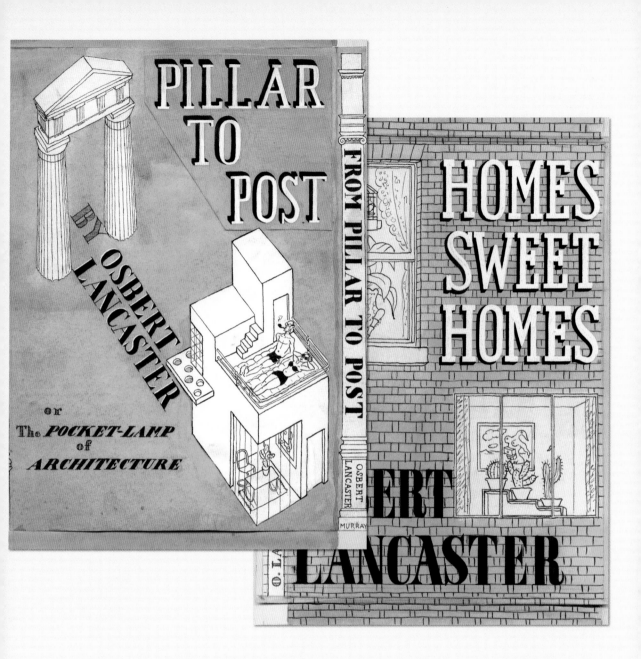

Pillar to Post, published in 1938, is an illustrated survey of British architecture from Stonehenge to twentieth-century functionalism. The remoter periods adopt the familiar terminology of established styles whereas later architectural developments are identified and classified by Osbert for the first time. Many of his labels such as Stockbrokers' Tudor and Pont Street Dutch have, in the words of Clive Aslet, editor of *Country Life*: 'infiltrated their way into the language of serious architectural history'. The book was twice updated after the war to include American examples as well as some new styles such as Pop Nouveau and High Rise.

Homes Sweet Homes was a companion volume published in 1939. It illustrates the interiors of the building styles Osbert identified. He felt passionately that interiors were just as much architecture as the façades and that they served to humanize the subject, reinforcing 'the lesson that architecture does not exist, and is not to be studied, in a vacuum'. All his drawings of architecture feature amusing figures and one must not forget that for him people are an essential part of architecture.

Gothic interior 'The upper classes began to interest themselves in the question of decoration and the plain white-washed walls of their Norman ancestors were hidden behind tapestries, painted canvas or frescoes.'

Norman (top left) 'An admirable, straightforward method of building'.

Elizabethan exterior (bottom left) 'more glass than wall'.

Early English (top right) 'Late in the 12th century a genius discovered a new method of vaulting'.

Elizabethan interior (bottom right) 'an atmosphere of oppressive and overwhelming richness'.

Baroque exterior (above)
'Vast flights of steps, innumerable statues, elaborate fountains were all pressed into service for the sake of a truly impressive effect.'

Baroque interior (opposite)
'A taste for the grandiose, like a taste for morphia, is, once it has been fully acquired, difficult to keep within limits... Seldom have architects achieved dwellings further removed from the definition as *une machine à habiter.*'

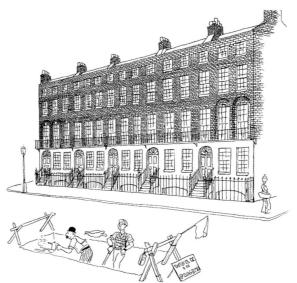

Early Georgian interior (above) 'A logical development of the Restoration apartment evolved by Wren and his followers'.

Georgian town (right) 'One of the greatest triumphs of English architecture'.

Louis XIV To be pronounced in a superior interior decorator's accent *louiscatorse* – 'the habit of receiving in bed, so popular with both sexes among the very wealthy and important, led to that apartment being decorated with uncommon luxury and pomp.'

Scottish Baronial interior
'Vast castellated barracks faithfully mimicking all the least attractive features of the English home at the most uncomfortable period of its development, and filled with rank upon rank of grim-visaged, elaborately kilted forebears'.

Scottish Baronial exterior
'Although the Scottish Baronial was primarily a domestic style, it is interesting to note that it was also extensively employed for prisons.'

Troisième République
(opposite) 'The boudoir, significantly enough, was the characteristic region of the house in this silver age of European culture.'

First Russian Ballet period
(above) 'A room not so much as a place to live in, but as a setting for a party'.

Greenery Yallery (left) 'The intellectual young woman could safely relax and lend a properly appreciative ear to the patter of Pater and whispers of Wilde.'

Pont Street Dutch (above left)
'The most remarkable features of
this new style were a fondness
for very bright red brick, a
profusion of enrichments in that
most deplorable of materials,
terracotta, and a passion for
breaking the skyline with every
variety of gable.'

Modernistic (above right)
'Enlivened by the addition of
quite meaningless scrolls and
whirls in a fiendish variety
of materials, ranging from
chromium plate to bakelite'.

Stockbrokers' Tudor

Interior (left) 'A glorified version of Anne Hathaway's cottage with such modifications as were necessary to conform to transatlantic standards of plumbing.'

Exterior (above) 'All over the country the latest and most scientific methods of mass-production are being utilized to turn out a stream of old oak beams, leaded window-panes and small discs of bottled glass.'

Twentieth-Century Functional

Exterior (left) 'The style which now emerged was one of the utmost austerity, relying for its effect on planning and proportion alone.'

Interior (above) 'The cactus sprouts where once flourished the aspidistra and the rubber-plant, the little bronze from Benin grimaces where smiled the shepherdess from Dresden.'

Early Skyscraper (opposite) 'The spectacle of so many free copies of the Sainte Chapelle and the Villa Medici hanging cloud-wreathed above the snow-line.'

High Rise (above) 'An imperfect understanding, on the part of builders, of the exciting new structural methods and materials made available by modern technology.'

THEATRE

In 1919, at the age of eleven, Osbert was taken by his mother to the Russian Ballet at the Alhambra to see Diaghilev's production of Sleeping Beauty. The 'dazzling beauty of the Bakst sets', he wrote, resulted in 'the first great aesthetic experience of my childhood'. There and then he formed an ambition to design for the stage which, as it turned out, was not to be fulfilled for more than thirty years.

In retrospect there were indications during the intervening period that Osbert was preparing himself for such a role. Much of his time at Oxford was spent acting in plays which included working with a guest director, Theodor Komisarjevski, who was acknowledged as one of the greatest experimentalists of the international stage. At the Slade School of Art he attended the course on stage design taught by Vladimir Polunin, the principle scene painter for Diaghilev, which was to stand him in excellent stead all those years later.

The chance to fulfil his childhood ambition occurred in 1951, when he was invited by the young choreographer John Cranko to design the sets and costumes for a ballet commissioned in celebration of the Festival of Britain, Pineapple Poll. The production, with Osbert's radiant sets and 'jolly jack tar' costumes, turned into the hit of the season. Overnight, Osbert became one of Britain's most sought after designers of ballet, opera and plays. It launched him on a career which spanned over twenty years.

Six commissions came from Glyndebourne Opera alone, but he also designed three classic ballets for Covent Garden, one of which, La Fille Mal Gardée, choreographed by Frederick Ashton, is still in production. His theatre work included two productions for the Old Vic. The critics were invariably united in their praise. The Times concluded that: 'When the history of Glyndebourne comes to be written, high in the roll of honour will stand the name of Osbert Lancaster who has the great gift of designing décor that invigorates every opera.'

His success was a tribute not just to his grasp of period and assurance as an artist but to his ability to seduce the audience into suspending their disbelief. To achieve this, Osbert drew upon his subtle powers of exaggeration to make every aspect of the world presented on stage 'slightly larger, brighter (or gloomier as the case may be), where every object is charged with a greater significance than in the world of everyday life'. His aim was to achieve a visual pitch equal to any music or dramaturgy. In this way, he sought to provide the audience with a theatrical experience that, in his phrase, was 'the full works'.

Osbert tweaking the moustache of Peter Pears, prior to the performance of *Les Mamelles de Tiresias*, an *opera bouffe* by Francis Poulenc performed at the Aldeburgh Festival in 1958. It was conducted by Charles Mackerras with Britten and Poulenc at two pianos.

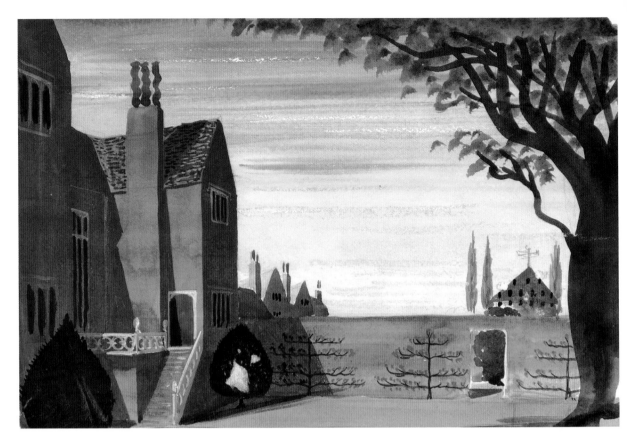

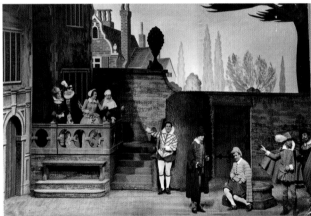

top: Verdi's *Falstaff*, Glyndebourne, 1955. A preliminary design for the backdrop of the garden of Ford's house. Commenting on his approach to the overall design Osbert wrote: 'Verdi has said in music all that needs to be said about the characters, the atmosphere, the background. All that can be asked of the designer is that his settings should be unemphatic and undistracting.' The production was revived three times over the next five years and televised in 1960. *The Times* suggested that Osbert's witty sets explained 'why so many people regard a visit to Glyndebourne as one of the greater delights of the musical year'.

above: Act 1 scene 2 of the 1958 revival. The merry wives stand on the balcony, the male quintet below includes the wealthy burgher, Ford (second right) and Falstaff's turn-coat companions, Bardolph (seated) and Pistol (far right). All are plotting revenge on Falstaff.

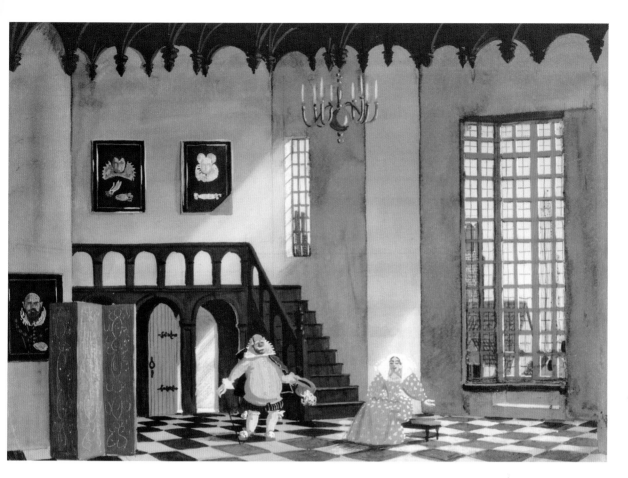

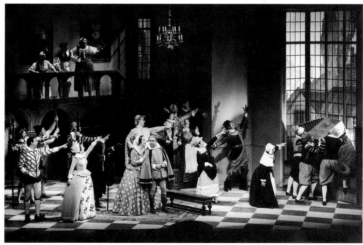

top: Osbert's design for Act 2 scene 2 with Falstaff making amorous approaches to Alice Ford. Osbert was concerned that his sets would appear too close in style to actual examples of 'Stockbrokers' Tudor'. 'The more correctly period the furnishings of Ford's house,' he explained, 'the stronger the feeling that the Southern Electric will whisk him to the Stock Exchange first thing on Monday morning.'

above: Act 2 scene 2 of the 1958 revival. Falstaff is bundled out of the window in a laundry basket into the Thames below.

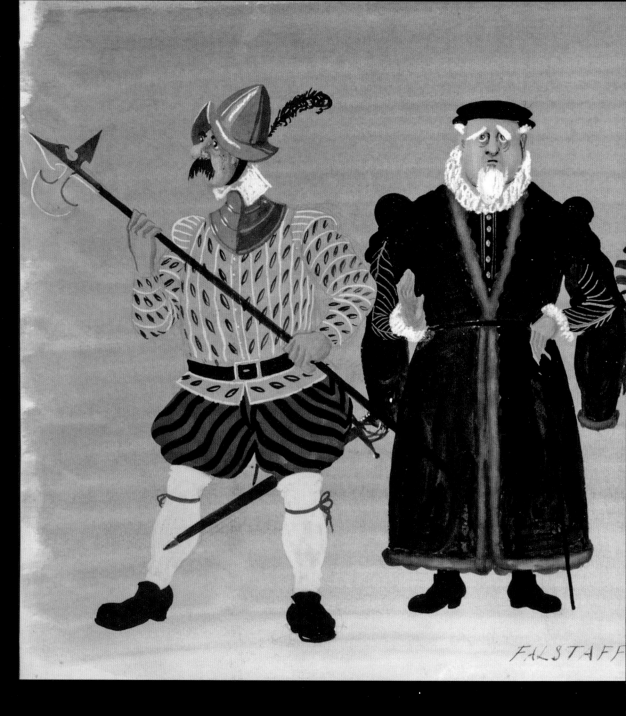

FALSTAFF

above: *Falstaff*, Glyndebourne
1955. Costume designs for Ford
and his followers in Act 2 scene
2 when they come in search of
Falstaff.

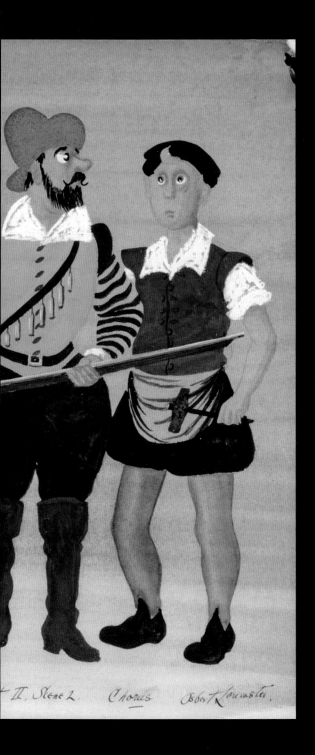

top: costume designs for *Falstaff* including Alice Ford (right).

above: preliminary costume sketches.

The appearance of Lady Godiva (above) and a dandy fox (top) reveal Osbert's fertile imagination.

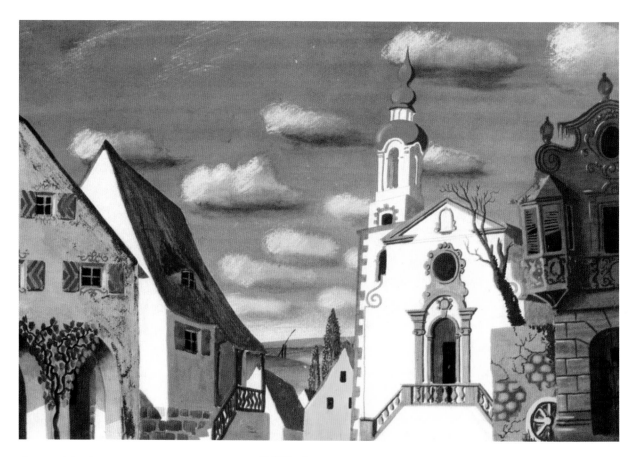

above: Backdrop for Act 1 of *Coppelia*, Sadler's Wells Ballet at Covent Garden, 1954. The scene is a village square in Galicia.

right: Preliminary design for the last Act of *Coppelia*, the evening setting for Coppelia's wedding celebrations.

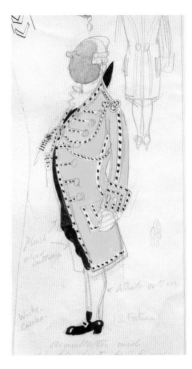

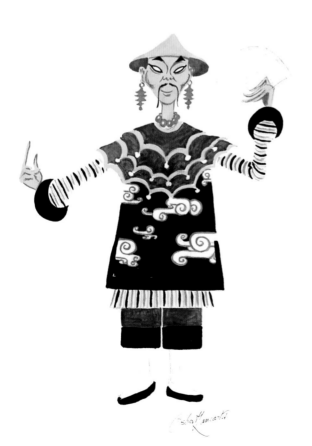

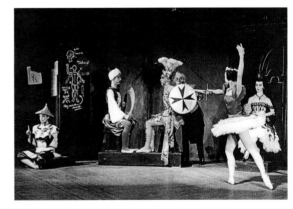

top left: Eighteenth-century figure drawn on the reverse of a cartoon.

top centre and right: Costumes for Oliver Goldsmith's play *She Stoops to Conquer* at The Old Vic 1960. It starred Peggy Mount, Judi Dench and Tommy Steele.

left: Costume design for the Oriental Doll in *Coppelia*.

above: *Coppelia*, 1954. Act 2. The Oriental Doll in Dr Coppelius's workshop with Swanhilda (Nadia Nerina) who dances with the dolls. Osbert's sparkling designs were credited with restoring panache to the 'well-worn' ballet resulting in 'the bloom restored to its charm'. His new look endured. In 1960 his sets were hailed as looking 'as pretty and evocative' as on their first outing.

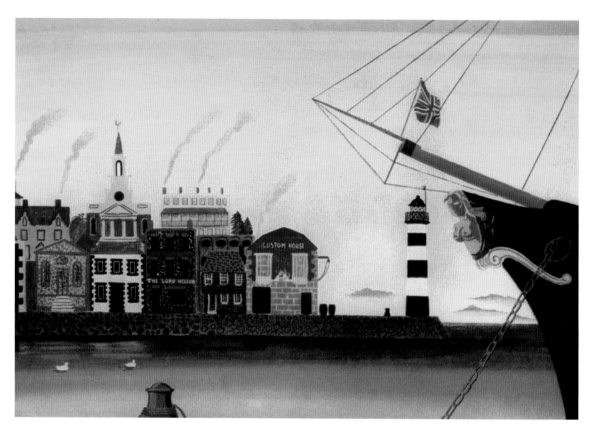

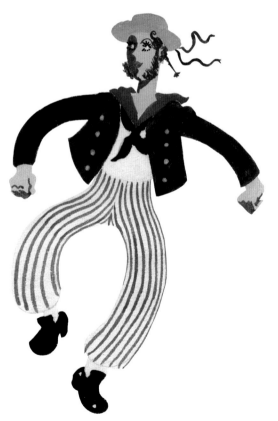

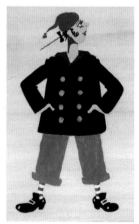

Pineapple Poll, Sadler's Wells Theatre, 1951. At John Piper's instigation Osbert designed his first work for the stage, *Pineapple Poll*. It was adapted from one W.S.Gilbert's *Bab Ballads*. The score was an arrangement of Arthur Sullivan's music by Charles Mackerras who was also the conductor.

top: Scene I, early morning, Portsmouth, circa 1830.

above and left: Costume designs for sailors, some of them women in disguise.

opposite: Flower seller Pineapple Poll in disguise, making eyes at the dashing Captain Belaye. Of the 1957 revival one critic wrote: 'Osbert Lancaster's hilarious décors strike the eye even more impressively.'

top: Backdrop for *The Rising of the Moon* by Nicholas Maw, premiered in 1970. The first contemporary work commissioned by Glyndebourne Festival Opera. The comic plot centres on the escapades of an English regiment billeted in a semi-derelict monastery. Tailor-made for Osbert, the period was set before the introduction of khaki 'so that the designer could have a chance to produce a collection of "Butterflies of War" – schapkas topped with swans' feathers, boots buffed with champagne; all as elegant and aristocratic as peacocks'.

above left: Costume design for Lady Eugenie Jowler, wife of the Colonel.

above (left to right): Nicholas Maw, Osbert and director Colin Graham working on the sets of *The Rising of the Moon*.

Osbert's designs for the 1953 Old Vic production of Shakespeare's *All's Well That Ends Well* starring Michael Hordern and Claire Bloom. On seeing the play Cecil Beaton wrote to Osbert: 'What a pretty job you've done with 'Allswell'... clever of you to make everyone look like one of your drawings.'

top: View of Florence.

left: Costume designs for French Lords.

above: Costume for Lavache.

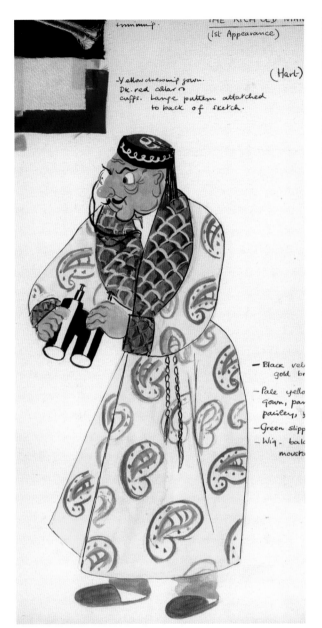

THE RICH OLD MAN
(1st Appearance)

(Hart)

-Yellow dressing gown.
Dk. red collar &
cuffs. Large pattern attached
to back of sketch.

- Black vel...
 gold br...
- Pale yello...
 gown, pa...
 paisleys, ...
- Green slipp...
- Wig - bal...
 moust...

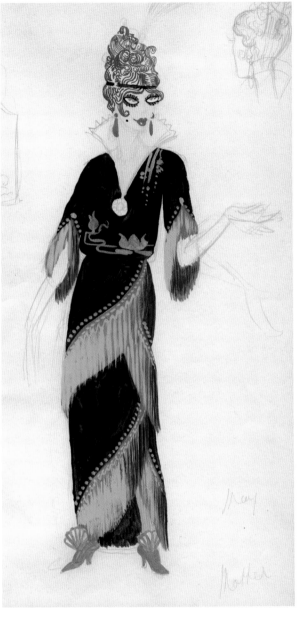

Bonne Bouche, Sadler's Wells Ballet at Covent Garden, 1952. This was Osbert's second commission from John Cranko and described as 'a riotously funny frolic' set in Edwardian Kensington and in Africa to music by Arthur Oldham. Rival designer, Cecil Beaton, wrote to Osbert: 'I must salute you – you have done such a wonderful job – it's utterly delightful – refreshing & so English … the costumes conjure up the character & epoch of the ballet & are essentially balletic – a Real talent for the stage has been neglected until now.'

above left: Costume design for The Rich Old Neighbour.

above right: Costume design for The Heroine's Mother.

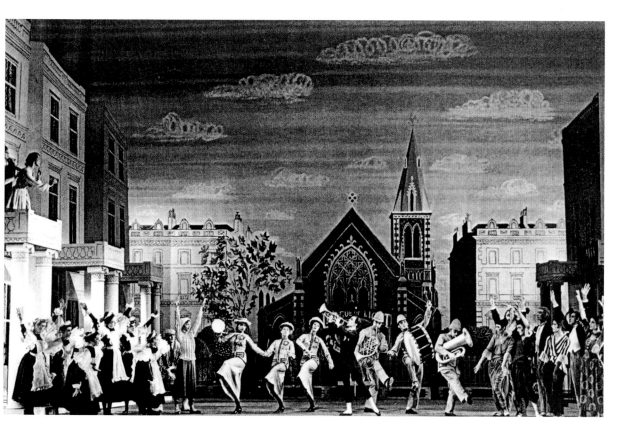

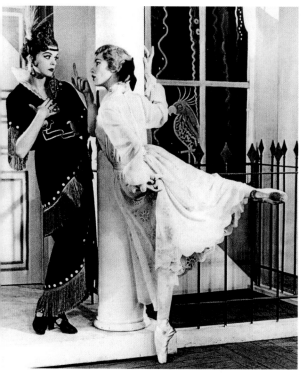

top: *Bonne Bouche*. Act 1 scene 1. Morning in South Kensington. 'The ranks of Kensington', commented the *Observer* critic, 'could scarce forebear to cheer when the curtain rose... to show Osbert Lancaster's charming vision of their homeland.'

left: The heroine, Pauline Claydon (right), and her mother, Pamela May. The Edwardian revival costumes and sets anticipated Cecil Beaton's 1956 designs for *My Fair Lady*.

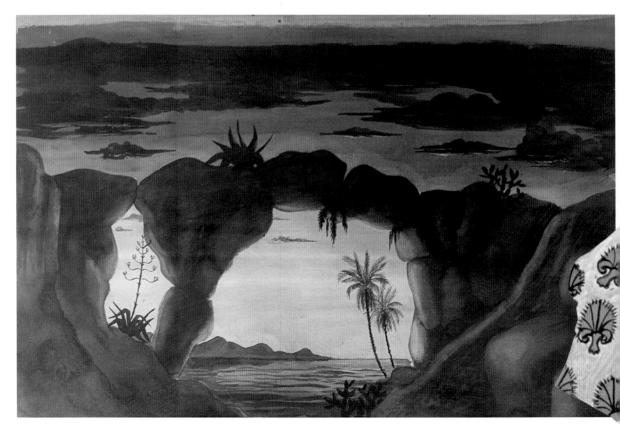

L'Italiana in Algeri, Glyndebourne, 1957. Osbert wrote that the music gave very little indication of how the opera, premiered in 1813, should look but it told 'a great deal about Rossini and his times'.

top: For the backdrop Osbert sought inspiration in that 'post-Napoleonic Italy of which so many souvenirs in the form of brightly coloured gouache views of Vesuvius survive in the remoter passages of English country houses.'

right: the finale of Act 1 scene 3. The Palace of the Bey of Algiers.

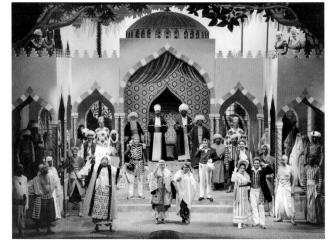

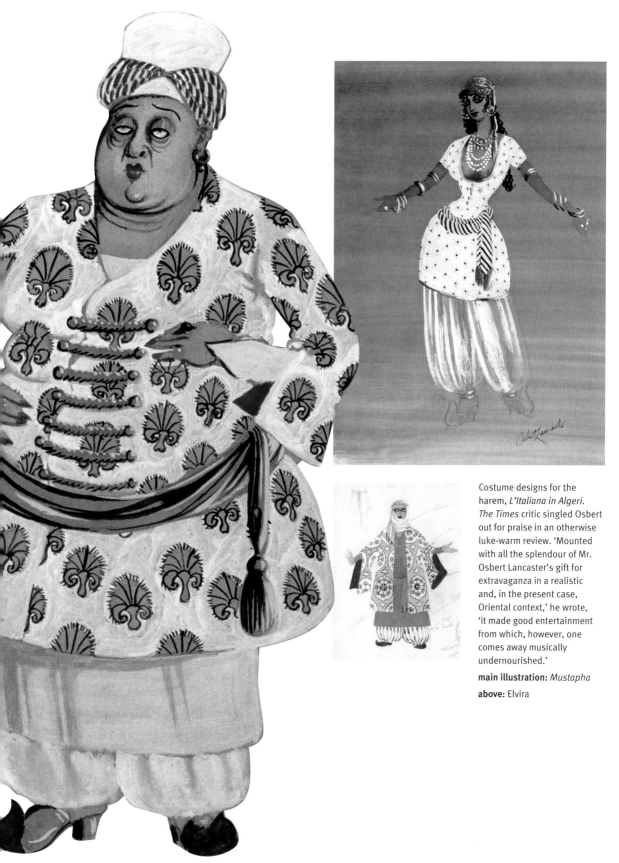

Costume designs for the harem, *L'Italiana in Algeri*. *The Times* critic singled Osbert out for praise in an otherwise luke-warm review. 'Mounted with all the splendour of Mr. Osbert Lancaster's gift for extravaganza in a realistic and, in the present case, Oriental context,' he wrote, 'it made good entertainment from which, however, one comes away musically undernourished.'

main illustration: *Mustapha*
above: Elvira

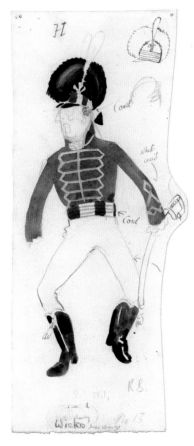

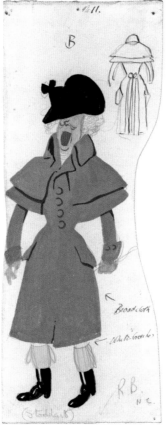

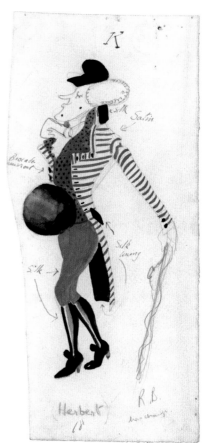

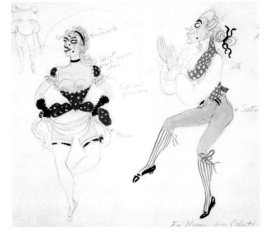

Stravinsky's *The Rake's Progress* was Osbert's first commission for Glyndebourne Festival Opera. It was originally staged in 1953 at the Edinburgh Festival. Osbert was a great admirer of Hogarth's 1730s cycle of narrative paintings which inspired the opera.

However he 'put the clock of fashion forward a few decades' to avoid clashing with the designs of the ballet of the same subject also opening at the Edinburgh Festival. His production was revived five times until replaced in 1975 by David Hockney's.

top: Costume designs for the Roaring Boys who, with the Whores, form the chorus in Mother Goose's brothel.

above left: Osbert acting as barber to mezzo-soprano Nan Merriman in the role of Baba the Turk, the bearded lady

above right: Dance in the brothel scene.

opposite: Costume design for Tom Rakewell.

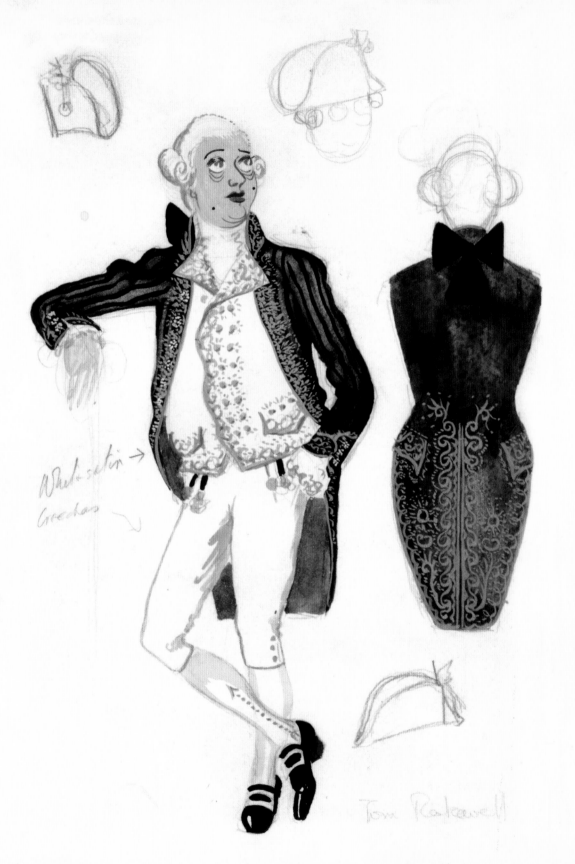

White satin breeches →

Tom Rakewell

right: From Osbert's series of great arias in opera. Don Giovanni (left) about to descend into Hell and Lohengrin (right).

below: This illustration records the original auditorium of Glyndebourne dating from 1934 which was widened in 1957 when the arched ceiling was installed. The building was demolished in 1992 and replaced with the current theatre, opened in 1994.

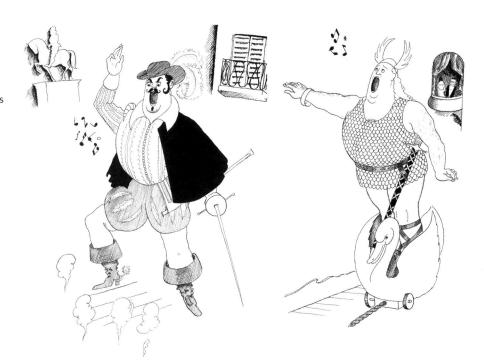

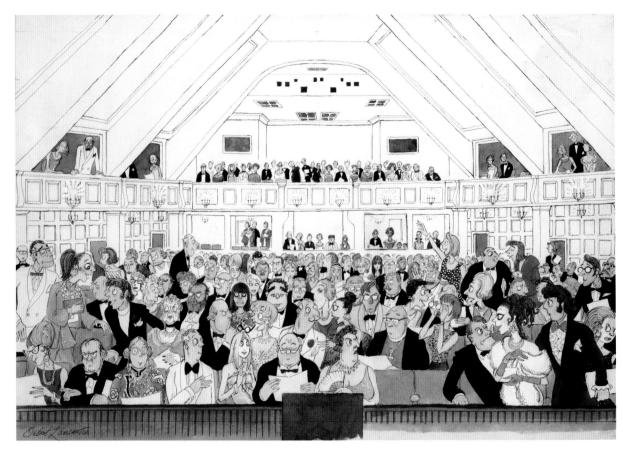

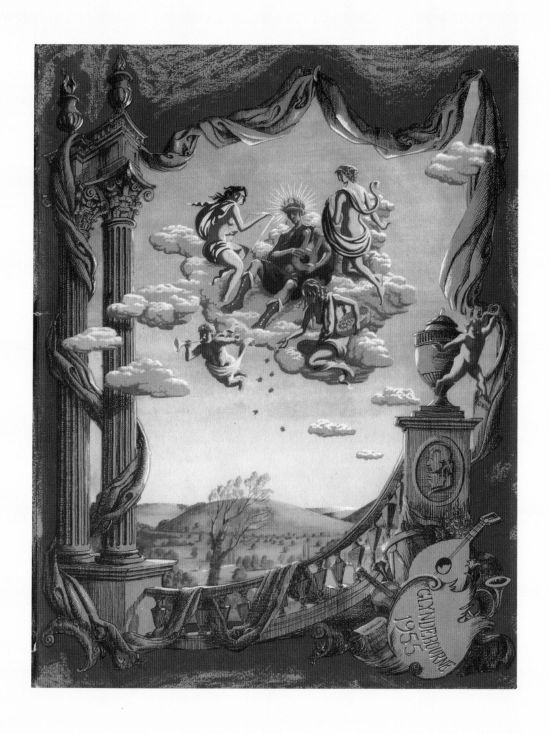

Glyndebourne's 1955
programme cover

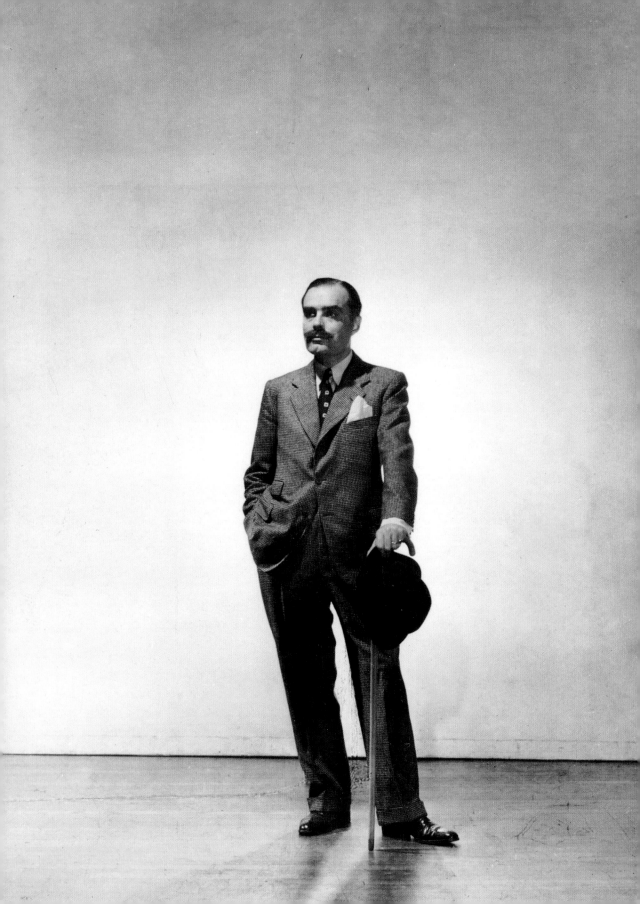

FASHION

Osbert was always passionate about clothes. One of his earliest memories was his appearance at his mother's 'Thursdays' in the drawing-room in Elgin Crescent: 'Clad in a *soigné* little blue silk number, with Brussels lace collar and cut steel buckles on my shoes.' Favourite reading matter as a child was old volumes of *Picture Post* with their photographic spreads of the sovereign families of Europe, padded torsos adorned with every variety of royal order, watered silk ribbons and tangles of gold cords.

Sartorially, Charterhouse had proved a grave disappointment and Osbert was to spend the rest of his life rebelling against its pettifogging regulations. 'As soon as I left school,' he explained, 'I had all my suits made with two button jackets, and I stick to them today, with only one done up, of course.' Oxford was the making of him. He affected pinstripes, checks, pink shirts, wide ties and, occasionally, a monocle. Alan Pryce Jones, a close friend, described the effect as Edwardian. 'Most people', Osbert confirmed, 'are fascinated by the period which lies just beyond their memory, and such glittering survivors of *la Belle Epoque* as came my way when young left a deep impression.'

Osbert had grown up at a time when clothes still defined social and professional distinctions and those, for him, added colour and meaning to the theatre of life. He lamented the passing of boatered milkmen and silk hatted stockbrokers, of costers in 'high-waisted pearl-decorated jackets' and bishops in gaiters. The dawning of that 'unattainable ideal', the classless society, banished such outfits to the dressing-up cupboard. A few survivors are recorded in the pocket cartoons, as well as the last flickering of dandyism in the neo-Edwardians and the teddy boys, but for the most part his interest turned to women. Accustomed from an early age to memorizing the details of regalia, he was ideally trained to spot the latest change in fashion, particularly in his muse, Maudie Littlehampton, and her trendy daughter, Jennifer. The 'New Look', the balloon dress, slacks, tights, the trouser suit and the mini all make their appearance on Osbert's pocket catwalk. As Anne Lancaster pointed out: 'Maudie's clothes are so up-to-date that they put even *Vogue* to shame.'

Osbert was well aware of the ephemerality of cartoons: 'if one looks through old copies of *Punch*,' he wrote, 'one gets the most pleasure from the ones with the most social document, what people were saying, what people were wearing, how people were behaving at that time.' His dedication to fashion, seemingly the most frivolous of arts, has ensured that Osbert's brilliant drawings have a longevity far beyond the burning topics of the day that provoked them.

Osbert in his mid-forties, and aged eight.

'As I told Maudie Littlehampton, one would never dream of dressing up like this if one didn't think one was helping the export drive.' (24 January 1948)

'But could one fail to recognise la Belle Comtesse Littlehampton?!' (8 August 1958)

'What I can't get straight about your civil war, Colonel, is whether George Washington was on Abraham Lincoln's side or Vivian Leigh's.' (7 November 1949)

'My dear, isn't it too awful! Some brute mistook poor Maudie Littlehampton's hat for a bookie's banner and slashed it to ribbons!' (16 June 1949)

'But, darling, its too simple – why,
one just goes into the sweetest little
cubby-hole and ticks off a lot of the most
extraordinary names of people one's
never heard of in one's life and see what
happens!' (14 July 1949)

'As soon as you're ready darling you can ring for an ambulance.' (27 October 1953)

'Maudie darling, please, just for today could we call a truce to all further speculation about the identity of the first life-peeress?' (17 June 1958)

'Isn't it wonderful to see the sun again?!'
(11 July 1958)

'Well, dear, I wouldn't back it too heavily
– Sir William Haley's crystal ball has
been a bit clouded recently.' (3 June 1959)

'Isn't it wonderful that we can now all relax for a bit and give our undivided attention to pre-marital intercourse and the Beatles.' (23 October 1963)

'Is it true that the whole thing has been organised by the Committee of a-thousand nine hundred-and-twenty-two?' (12 July 1963)

'Let it ring! Ten-to-one it's just another leaking Cabinet minister.' (19 December 1967)

'Tell me, darling, what exactly is it that your American pals are giving Thanks for – us?' (26 November 1965)

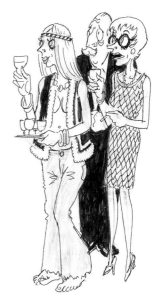

'Willy, darling, doesn't it make you rather proud to think that your daughter's become a prominent Alternative-Society hostess?' (27 August 1975)

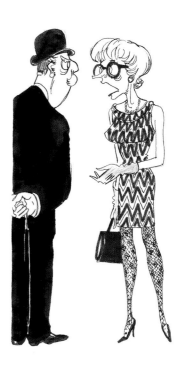

'Say what you like about Harold Wilson, he's loyal to his colleagues. Why, I'm assured that he's given a firm undertaking to go on and on and on until every member of his government is fully signed up with a good publisher for his or her memoirs.' (7 May 1969)

'Tell me, Sir Alberic, how do you all fill in your time at the Foreign Office now that so much of your work has been taken over by the Ministry of Pensions?' (10 July 1965)

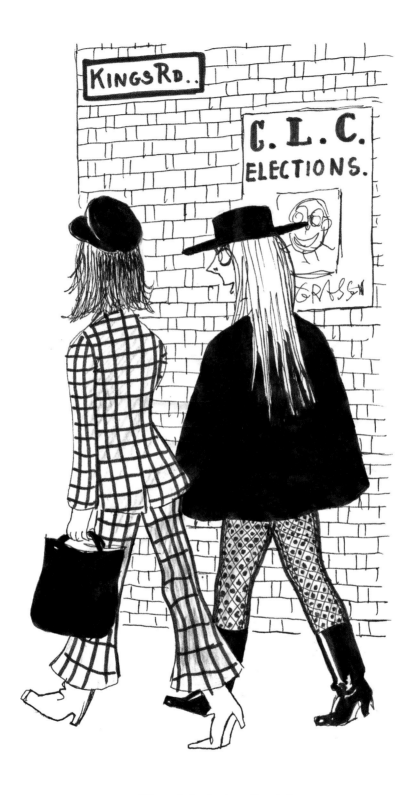

*'Whoever's standing here will neglect
the Psychedelic vote at their peril!'*
(18 March 1967)

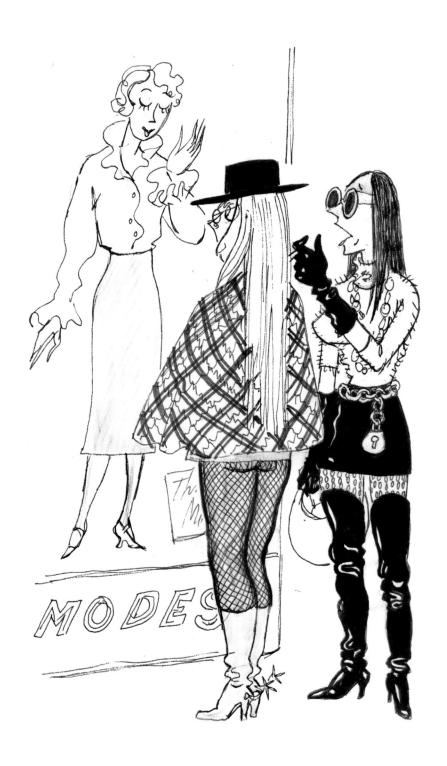

'Honestly, darling, you can't! It's really
TOO kinky!' (29 December 1967)

'Now tell me, Leofric, you're in the Foreign Office, exactly what is a 'week-end suit'?' (29 November 1966)

'Cheer up, darling, and let auld acquaintance be forgot! Here's to 1969, the first flight of the Concorde and teething troubles in two langages!' (1 January 1969)

'And now for free pot on the National Health! Marchons!!' (9 January 1969)

'Isn't it odd how every time we have a trade surplus everything goes up!' (12 December 1969)

'For heaven's sake, Maudie, do please remember that this is an inter-parochial not an international event.' (26 July 1966)

Questioned on the new fashion, the Archbishop of Canterbury, Dr Ramsey, said yesterday that the worst attitude for Church people to adopt towards new dress fashions was being shocked. (2 July 1964)

'But do you realise that if Nabarro is right it will be the first recorded instance of this government ever having taken a decision more than twenty-four hours ahead!' (4 February 1969)

(8 May 1969)

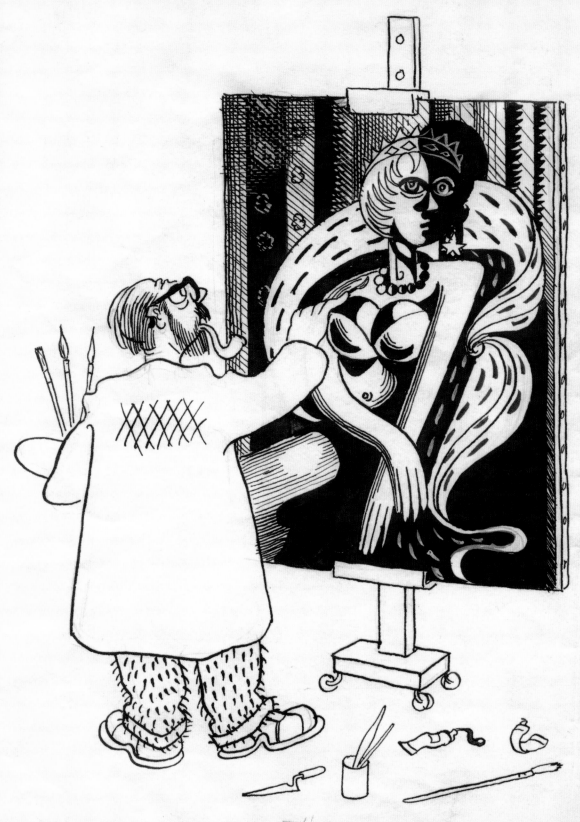

3/4

THE LITTLEHAMPTON BEQUEST

In 1973, the National Portrait Gallery in London, under the direction of Dr Roy Strong, staged an exhibition entitled *The Littlehampton Bequest*. It was a series of artistic parodies, drawn by Osbert, purporting to be the historic portrait collection of the Littlehampton family. A book of the same title was published to coincide with the exhibition, which reproduced each portrait alongside a 'scholarly' commentary embellished with the opinions of actual scholars as well as diarists of the period.

Ever since the emergence of Maudie Littlehampton as the star of his pocket cartoons, Osbert had been dreaming up earlier members of the family to entertain his readers. The Crusader Knight in *The Saracen's Head* was William de Littlehampton, while a brace of Earls had featured in *Drayneflete Revealed* as 'improvers' of Drayneflete Castle. *The Littlehampton Bequest* gave him the opportunity to trace the definitive family tree which began with Dame Agnes de Courantsdair, the only surviving child of the last Earl of Littlehampton of the first creation who was beheaded during the Wars of the Roses. She and her 'tycoon' husband laid the foundation for the family's relentless social ascent.

At every key moment of Britain's history, a Littlehampton was invariably on hand to reap the benefits, whether it was acquiring Drayneflete Abbey at the Dissolution of the Monasteries or an Earldom from William II after the Battle of the Boyne. Not all were success stories. The family threw up its fair share of dim sportsmen, rakes and swells, but whenever funds ran low, they married into Trade. In parallel to the social history of the family, Osbert also recorded – and depicted through his brilliant parodies - a history of British art and taste which was based on his own genuine scholarship. He charted the remodelling of Drayneflete Abbey, the impact on country house collections of the Grand Tour and, above all, the development of painting in Britain from the school of Holbein to David Hockney.

Dr Strong gave an accurate estimate of Osbert's achievement when he wrote of *The Littlehampton Bequest*: 'Osbert Lancaster has done more for the heritage of Britain through wittily sending it up than most of the people who have spent their lives writing enormously learned tomes on British painters and architecture.'

The Countess of Littlehampton sitting for her portrait, and the portrait painter at work, from *Façades and Faces* (1950).

Maudie inspired many of Osbert's earliest parodies. A 1960 series, which appeared in the *Cornhill Magazine*, included likenesses by Van Dongen, Munnings and Augustus John. 'Few women of her generation', he wrote, 'have displayed so sustained, albeit personal, an enthusiasm for art.' His assurance as a parodist reached its peak in *The Littlehampton Bequest*.

**Viscount Drayneflete
– Anthony Van Dyck**
(above) A staunch royalist
during the Civil War,
Christopher de Courantsdair
accompanied Charles II into
exile. At the Restoration his
estates were restored to
him and he was raised to
the peerage. The Viscount
was 'equally popular with
both sexes', winning him the
sobriquet 'the Wicked Lord'.

**Benjamin
Wouldbegood-Courantsdair
– School of Holbein**
(top right) Sir Benjamin, who
was knighted by Henry VIII,
was grandson of the last Earl
of Littlehampton of the first
creation. A key adviser to the
King, he acquired in 1548, at
the time of the Dissolution of
the Monasteries, 'for a very
reasonable sum', the lands and
buildings of Drayneflete Abbey.

**'Cleopatra'
– Lucas Cranach the Elder**
(above right) The model
for this picture became Sir
Benjamin's second wife. He
demanded to meet her having
first seen the picture in the
artist's studio whilst on a
diplomatic mission to Saxony.

The 2nd Earl of Littlehampton – James Seymour

(top) Not gifted with many brains, he was a superb horseman and 'highly thought of in local cockfighting circles'. He married a Miss Grosgrain, said to have been from an old Huguenot family. The diarist Hervey claimed she was a still-room maid. Politically, he remained a staunch Whig.

The Reverend The Hon. Dr. Lancelot de Courantsdair – George Stubbs

(middle) The younger son of the first Earl, who became rector of one of his brother's best-endowed livings. A keen archaeologist, he excavated a Druidic dolmen in his kitchen garden. He also wrote epic poetry.

Aubrey de Courantsdair – Nicholas Hilliard

(above left) The younger son of Sir Benjamin by his Saxon wife. As a young man, he spent some years in the household of the Earl of Southampton, although the theory that he is the original Dark Lady of Shakespeare's sonnets is disputed. He also became (until he put on weight) a great favourite of James I.

Vanessa, Countess of Littlehampton and her daughters – Marcellus Laroon

(above) The wife of the 1st Earl was heiress to half the plantations in the West Indies. She is portrayed with her two daughters and her page, Hasdrubal, who in her widowhood 'was always about her person'.

**Joseph Grumble Esq.
– Johannes Zoffany, R.A.**
(above) Born in humble circumstances, Grumble became a vastly rich nabob in the East India Company. On retiring to England he acquired the neighbouring estate of Drayneflete Magna. His daughter, also pictured, went on to marry the 3rd Earl.

**Sir Ebenezer Horseferry, Bt and family
– William Mulready, R.A.**
(opposite left) A second generation ironmaster from Yorskshire, Sir Ebenezer made a fortune out of the railways. He received a baronetcy for his work on the Great Exhibition. The baby on his knee became the 6th Countess.

**The Rt Reverend Bishop Fontwater
– from an engraving by J. Phillips**
(opposite right) As a penniless curate, Aloysius Fontwater married the plain half-sister of the 3rd Earl (with the latter's blessing). Thanks to his Whig connections, he ascended the Anglican hierarchy and was the last bishop to regularly wear a wig in the House of Lords.

**The Countess of Littlehampton
– Canova**
(right) The second wife of the 3rd Earl inherited her father's fortune made in India. She was sculpted by Canova on a visit to Rome with her Grand Tourist husband. Through her son by her third husband, a diplomat, she is the direct ancestor of Maudie Littlehampton.

CANOVA SCULPSIT

**The Last Charge of
the 27th (detail)
– Lady Butler**

(above) The second son of the
6th Earl leading the charge in
the Second Matabele campaign.
He went on to serve as a
cavalryman in the Boer War and
the First World War, ending his
career as a General. During the
last war, whilst commanding the
Drayneflete Home Guard, he was
blown up defusing a bomb.

**'Ourselves and Tum-Tum'
Drayneflete, Christmas 1904**

(right) The 7th Countess,
daughter of a Central
European financier, out for
a drive with Edward VII,
of whom she was a great
favourite. Her husband,
Cosmo, a lover of the Turf,
sits in front. Their marriage
broke up the following year.

'Ursula'
– Mark Gertler
(above) The daughter of Cosmo and Charlotte Littlehampton. She inherited an artistic strain from the Horseferry side of the family and having trained at the Slade she took a studio in Fitzroy Square. Always left wing, she married a Croatian economist and remains active in the struggle for equality.

Charlotte, Countess of Littlehampton, on her marriage
(above right) The second wife of Cosmo Littlehampton was an actress from Tulse Hill where her father was a publican. Her business acumen soon set the earl's finances in order. She also produced the longed for heir, Willy, the current Earl.

Charlotte, Countess of Littlehampton at the Coronation of H.M.King George VI
– Cecil Beaton
(top right) Apart from her family, the Countess's main interests were charity and the Conservative party. Her political affiliation brought to an end the Whig tradition in the family. She died in 1952 universally mourned.

'Jennifer'
– John Bratby
(above) The daughter of the
8th Earl and Countess, Willy
and Maudie, is a rebel who
was caught pushing cannabis
at Queen Charlotte's ball.
A member of the Chelsea
set, a social worker, novelist
and theatrical producer,
she is also a single mother,
currently writing her
autobiography in Majorca.

Willy, Viscount Drayneflete
later 8th Earl of Littlehampton
– Sir Oswald Birley R.A.
(above right) in the uniform of
the Household Cavalry painted
at the time of his marriage. The
current Earl, who succeeded his
father in 1937, had a 'good' war
which included escaping from
Rumania disguised as Princess
Bibesco. His effectiveness
in the Lords facilitated the
passage of the Hedgehog
Protection Bill. While his 'tact
and discretion' in local affairs
led to re-routing the M17
through a neighbour's park.

Maud Manifest (later Countess
of Littlehampton)
– Philip de László
(top right) Maudie, the
daughter of a baronet, is
a descendant of the 3rd
Countess (see Canova's
sculpture) from whom she
inherited her looks. One of
the most formidable operators
in London Society, she
negotiated the transfer of
the Littlehampton Collection
to the nation – much to the
relief of the letters' editor
of *The Times*.

Viscount Drayneflete (from the sleeve of his current L.P.)
(left) Son and heir of the 8th Earl and Countess, the Viscount started life as a photographer before forming his own highly successful pop group, the Draynes. He currently enjoys a Saturday-night 'spot' on ITV. Married to a Miss British Honduras 1971, he lives in a mansion in St George's Hill, Weybridge.

Basil Cantilever Esq. and the Lady Patricia Cantilver – David Hockney
(above) The second daughter of the present Earl married Basil Cantilever, who is now M.P. for Drayneflete. An architect and developer, he demolished St. Ursula-inside-the-Wardrobe in the City, which has had long connections with the Littlehamptons, to build a 30-storey office block.

JACKETS AND ILLUSTRATIONS

Osbert received his professional training at three art schools, the Byam Shaw, the Ruskin and the Slade. His teaching draughtsman at the Ruskin was the prolific commercial artist, Barnett Freedman. Not only was he an excellent teacher, but he also demonstrated how to earn a living without compromise. 'With the exception of McKnight Kauffer,' wrote Osbert, 'no man in this country did more to restore the standards of commercial art.' His sense of an artist's worth made a life-long impression on Osbert. One of his most important lessons was the necessity of demanding a fair rate of pay from advertisers and publishers.

On leaving the Slade in 1932, Osbert swiftly grasped the economic realities of being an artist. To augment his income from sales of his paintings, he opened for business as a commercial artist. However, the offer of an editorial post with the *Architectural Review* soon diverted him from this course. Over the next few years, he wrote as much as he drew, but his portfolio was augmented by his brilliant jacket designs and illustrations of his own architectural satires. His commercial practice took off in the 1950s with commissions flowing in from magazine and book publishers. He designed book jackets for many of his old friends, such as Nancy Mitford, Anthony Powell and Alan Moorehead who, like him, were at the peak of their careers. Other commissions included C. Northcote Parkinson's bestseller *Parkinson's Law*, and numerous titles by P. G. Wodehouse.

A key to Osbert's success was his love of literature. He was a voracious reader of English and French authors and often observed the world through their eyes. Reporting to his publisher Jock Murray on a political soirée, he concluded: 'the chief impression I carried away, was how singularly well Disraeli had managed his big political party scenes in *Lothair*.' He was also steeped in the English tradition of illustration, first discovered at school through the work of old Carthusians, Thackeray, Leech and Beerbohm. His description of the pre-war Isle of Wight was typical of his visual literacy: 'one entered a steel-engraved world… the chain pier invested the children and donkeys on the sands below with all the period animation of a drawing by Leech.'

No period or style was beyond the reach of Osbert. 'The English', he wrote, 'are a nation of illustrators … For us 'art for art's sake', 'significant form' etc. are far less potent and productive slogans than 'every picture tells a story'; all our best artists, or nearly all (Rowlandson, Hogarth and frequently Sickert) are raconteurs.' And Osbert was among the best of them.

Self-portrait, 1948. Osbert habitually worked at home in the mornings robed in one of his exotic dressing gowns acquired in the Middle East. This was the time spent on freelance work such as book illustration and jacket design. At noon he would dress and prepare to face the world.

Osbert wrote and illustrated, *The Saracen's Head,* published in 1948 and dedicated to his children, Cara and William. Cara coloured in some of the blue. It is the tale of William de Littlehampton, a reluctant crusader, who, despite his incompetence at knightly pursuits, returns in triumph, knighted for his heroism and with a Byzantine princess as a bride.

above: Artwork for the jacket of *The Saracen's Head*. On the left is William de Littlehampton setting off for the crusade bearing his father's coat of arms accompanied by his disobedient wolfhound, Charlemagne. On the right, a bronzed Sir William returns from the Crusade bearing the arms granted to him by Richard I, 'a severed Saracen's head proper'. Charlemagne's tail has been bitten off by a lion.

top: Sir William as standard bearer to the King at the siege of Acre. The day ended in victory with William planting the standard on the battlements.

above left: William's fearsome mother waving him off. His loathed cousin Leofric, who excelled in all knightly pursuits, holds William's horse.

above right: William prepares to take on the Saracen lord, El Babooni, who had already dispatched two crusaders. Charlemagne watches on in the bottom lefthand corner. William's inability to keep a straight lance so confused his opponent that he was skewered.

Cover artwork for the short–lived but fashionable weekly, *Night and Day*, 1937. Osbert was also art critic for the magazine which set out to emulate the *New Yorker*.

Its nemesis was the film star Shirley Temple, who was libelled by the film critic Graham Greene. The court awarded in her favour and the magazine went out of business.

top left: A new edition of a history of the Great Exhibition to coincide with the Festival of Britain. The author, Christopher Hobhouse, one of Osbert's closest friends, had been killed in the war.

top right: Jacket artwork for a history of the English Gentleman (1961) by the raffish Simon Ravon.

bottom left: Jacket for the American reissue in 1961 of Powell's pre-war novel. Powell particularly liked 'the young man with the turned down collar and white tie'.

bottom right: Jacket for the biography of the ghost hunter Maude ffoulkes, 1967, by Violet Powell, wife of Anthony.

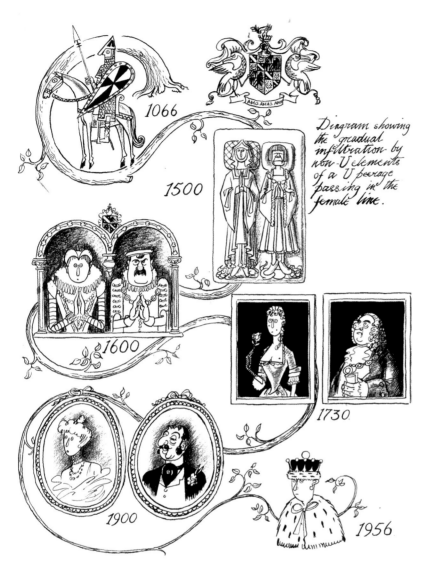

1066

1500

Diagram showing the gradual infiltration by non-U elements of a U peerage passing in the female line.

1600

1730

1900

1956

above and right: Frontispiece and jacket for *Noblesse Oblige,* edited by Nancy Mitford, 1956. Osbert, a connoisseur of social distinctions, was the perfect choice to illustrate Nancy Mitford's classic edition of essays on Upper Class English Usage, which popularised the concept of U and non-U. Other contributors included Professor Alan Ross, who invented the terminology, Evelyn Waugh and John Betjeman with his poem 'How to get on in Society'. The book caused a sensation. Osbert returned to the topic in a pocket cartoon which had Maudie declare: 'If it's me, it's U.'

top: Artwork for the jacket of Baroness Agnes de Stoeckl's autobiography – 'a transcontinental romantic journey'.

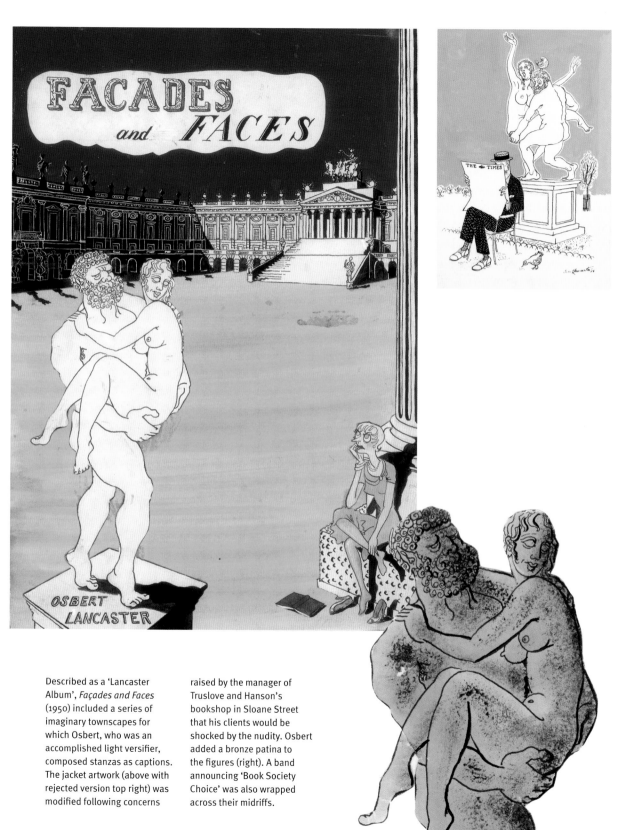

Described as a 'Lancaster Album', *Façades and Faces* (1950) included a series of imaginary townscapes for which Osbert, who was an accomplished light versifier, composed stanzas as captions. The jacket artwork (above with rejected version top right) was modified following concerns raised by the manager of Truslove and Hanson's bookshop in Sloane Street that his clients would be shocked by the nudity. Osbert added a bronze patina to the figures (right). A band announcing 'Book Society Choice' was also wrapped across their midriffs.

Three illustrations for the paperback editions (1962-68) of Anthony Powell's sequence of novels, *A Dance to the Music of Time*. Osbert was a close friend of Powell and an ardent fan of his writing. He loved Powell's sense of period, especially when it coincided with his own experiences. Powell returned the compliment by hanging his favourite Lancaster drawings in his bedroom. Osbert was summarily removed as illustrator before the series was completed, due to the imposition of a 'New Look' at Penguin in the swinging sixties.

clockwise from above left: Mrs Wentworth and Lady Ardglass; Widmerpool; General Conyers playing the cello.

opposite: Rough artwork for the jacket of *Company for Henry* by P.G.Wodehouse (1967). One of numerous Osbert jackets designed for the Master.

Three preparatory studies for Max Beerbohm's *Zuleika Dobson*. Osbert wrote to Max Beerbohm to seek his blessing in carrying out the Randolph Hotel's commission to paint a series of panels illustrating the story of Zuleika Dobson.

top: The Duke of Dorset entertaining Zuleika to tea on the Judas College barge just before they watch the Judas eight bumping Univ.

above left: Extract from Max's encouraging letter to Osbert.

above right: Max's own sketch of how he visualised Zuleika.

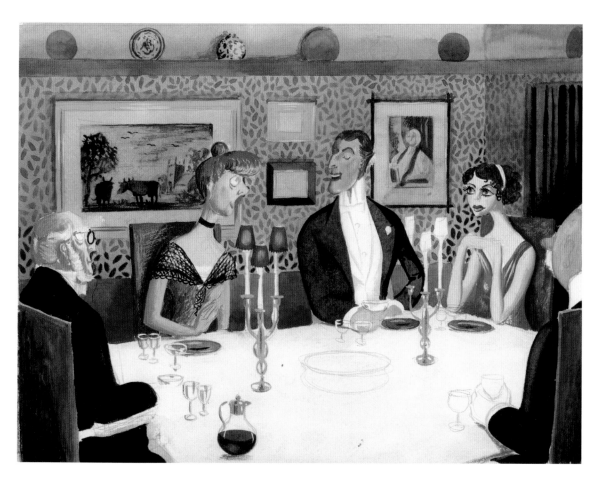

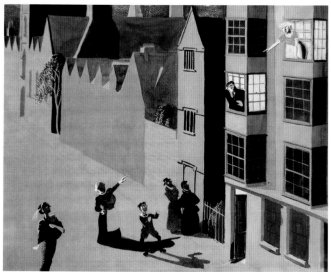

above: Zuleika at dinner on her first night at Oxford, with her grandfather the Warden of Judas, together with a don from Oriel, his wife and the Duke of Dorset. 'She did not look like an orphan,' said the wife of the Oriel don, subsequently.

left: The fatal exchange between Zuleika and Noaks, the last surviving undergraduate, whom Beerbohm instructed should look 'pale and hideous'. Katie, the spurned landlady's daughter interjects: 'Oh, you're welcome to him.'

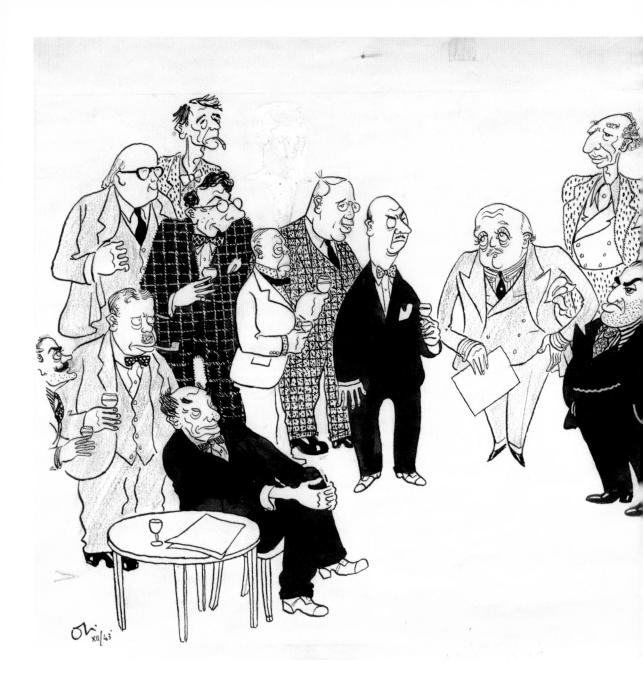

above: The first meeting of the Maximilian Society, August 1942, to celebrate Max's seventieth birthday. Max described the cartoon as: 'Osbertianly *impayable* [priceless], and continues to keep me in fits of laughter'. Members include: seated, Desmond Macarthy; standing 2nd left in checked suit, Raymond Mortimer next to the diminutive Sir William Nicholson; on Max's right, Lord Berners, on his left, Philip Guedella with, behind, Clough Williams Ellis; back right, seated group, Charles Morgan, Cyril Connolly, Tom Driberg and Logan Pearsall Smith, below latter in profile, T.S.Eliot. The cartoon was drawn two years after the event. Osbert is glimpsed in profile, extreme left, storing the occasion in his remarkable visual memory.

right: Max Beerbohm, Old Carthusian, dandy, parodist and caricaturist, who was Osbert's idol.

top right: George IV as Prince Regent. In *Our Sovereigns*, Osbert's survey of British monarchs, one of the most sympathetic portraits is that of George IV. Brushing aside his political and personal failings, he lauded him for his 'genuine though opulent taste' in architecture and for 'the encouragement he gave to the town planning schemes of the architect Nash'. Assessing his achievement in the *Architectural Review*, Osbert wrote elegiacally: 'When the bewigged and corseted old paladin, with his cherry brandy and his sultanas, his bijouteries and his charm, passed away, there perished with him the whole eighteenth-century concept of the tradition of the royal builder.'

above right: Edward VII, Osbert's favourite monarch. He argued in *Our Sovereigns* that despite Queen Victoria's best efforts to exclude him from the burdens of office, Edward went on to become 'one of the most enlightened of contemporary monarchs' with a brilliant diplomatic and political touch. 'His affability,' Osbert wrote, 'his dandyism, his sporting activities and his indiscretions all served to render him a familiar and beloved figure not only to the man about town but also to the man in the street.'

*The Englishman's profound horror
of any sartorial ostentation, fostered
by education...*

...reinforced by tradition,

...at every stage of his career,

...and common to all classes,

A series of lithographs for the
Coronation issue, June 1953, of
the *Ambassador* magazine. As

Osbert once observed of a pre-war
Levée at St James's Palace, these
examples of dandyism are 'a

convincing demonstration of the
truth that whereas women dress
up to impress men, so do men.'

...of society,

...in every part,

...of the United Kingdom,

...naturally makes it very difficult for him to comprehend the foreigner's passion for fancy dress.

For Jack with many thanks from.

Osbert, who is not working nearly as hard here— as he was made to at

DAILY EXPRESS

MR. MURRAY N.B.

1961

JEUX AND CHRISTMAS CARDS

Jock Murray recalled that whenever Osbert dropped in at 50 Albemarle Street 'he added to the excitement of life'. Everyone was cheered up by his jokes and gossip as well as by his drawings for invitations and menu cards for the staff dinners. Indeed, each visit was celebrated by continual doodling. He happily drew cards announcing books by other authors and loved writing elaborate inscriptions in his own. By the time of his departure drawings were scattered all over the house, which were then carefully collected up for the archive.

Osbert's festive spirit shines forth in his Christmas cards. He started the tradition of drawing his own cards in 1930, fresh down from Oxford, and the first few years featured uniformed flunkies and military types. In time, the subjects began to reflect the many aspects of his crammed working life: Maudie hovers on stage surrounded by her *corps de ballet,* with Willie prompting in the wings; an ancestor looks down upon the family as Willie reads the lesson. One year, he illustrates a house in the style of 'Second Empire Renaissance' occupied by a lady of Edwardian vintage. Elsewhere, Osbert's belief in the Christmas message is handled with a characteristically light touch reflecting, as he admitted, 'that embarrassment induced in all right thinking men by any mention of God outside church.'

Osbert's gift of celebration – his ability to turn every occasion into an event – sprang from a lesson first learnt at Oxford from his mentor Maurice Bowra – 'that opportunities for enjoyment were to be grasped wherever found.' His daughter Cara cites his recitals of operatic gems and German *lieder*, played very badly on the piano, martini to hand, before lunch and dinner. Her mother, who had perfect pitch, sang along, interposing the occasional swear word. In Cara's view, these family concerts – noisy, rude, cultivated and fun – characterized Osbert's supreme quality as a life enhancer.

Inscription to Jock Murray on the half-title page of his cartoon collection, *Sign of the Times 1939-1961*, published in 1961. In order to encourage Osbert to write the prefaces to his collections, he was often barred from leaving 50 Albemarle Street until they were complete.

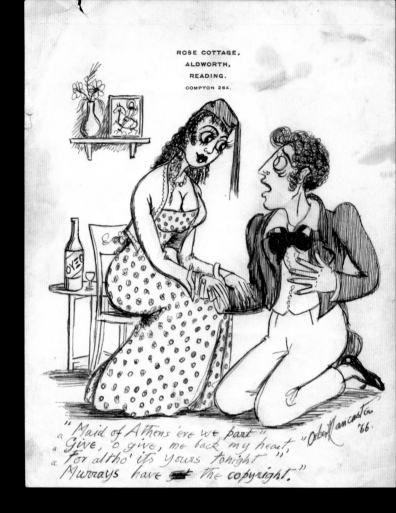

Given to Jock Murray on
the discovery of a new Byron
letter in 1966:

Maid of Athens 'ere we part
Give, O give, me back my heart
For altho' it's yours tonight

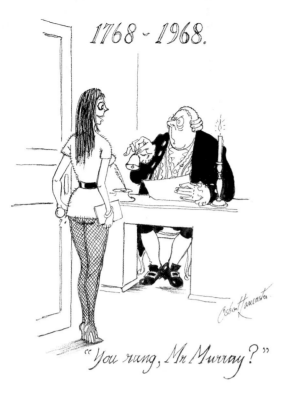

1768 - 1968.

"You rang, Mr Murray?"

The new secretary surprises the first Mr Murray! An illustration for the Murray bicentenary dinner menu.

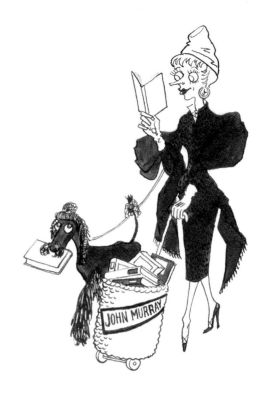

Maudie promoting her publisher's wares.

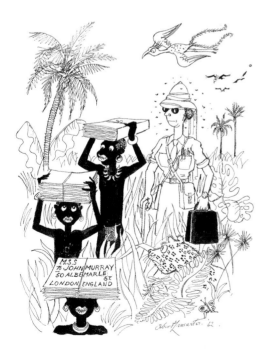

A John Murray author in the footsteps of explorer David Livingstone also published from 50 Albemarle Street.

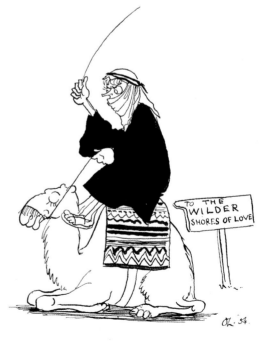

Inspired by Lesley Blanch's classic Murray bestseller *The Wilder Shores of Love*.

After Breakfast at Kelmscott.

above: Osbert and John Betjeman often visited William Morris's house at Kelmscott in Oxfordshire, which remained the home of his daughter, May Morris. The earth closet with three seats inspired his illustration (left to right): William Morris, Janey Morris and Dante Gabriel Rosetti. Osbert, who in his early days scorned Victorian taste, deemed William Morris's wall papers 'the only legacy of any artistic value'.

opposite: The Three Kings. A Christmas card expressing Osbert's enthusiasm for all things Byzantine.

Maudie taking centre stage
in a production of 'The Fairy
Dell', with Willy in the wings
Christmas 1963.

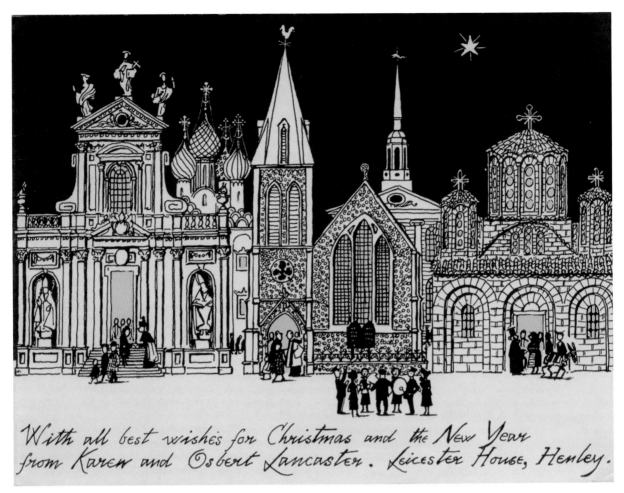

With all best wishes for Christmas and the New Year from Karen and Osbert Lancaster. Leicester House, Henley.

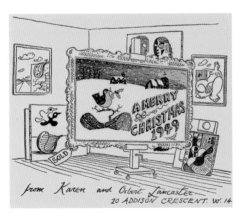

from Karen and Osbert Lancaster 10 ADDISON CRESCENT. W. 14

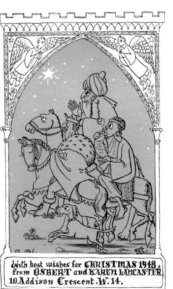

With best wishes for CHRISTMAS 1948 from OSBERT and KAREN LANCASTER 10 Addison Crescent. W. 14.

top: Ecumenical Christmas card
above: 1949 Christmas card
right: 1948 Christmas card
opposite: 1950 Christmas card

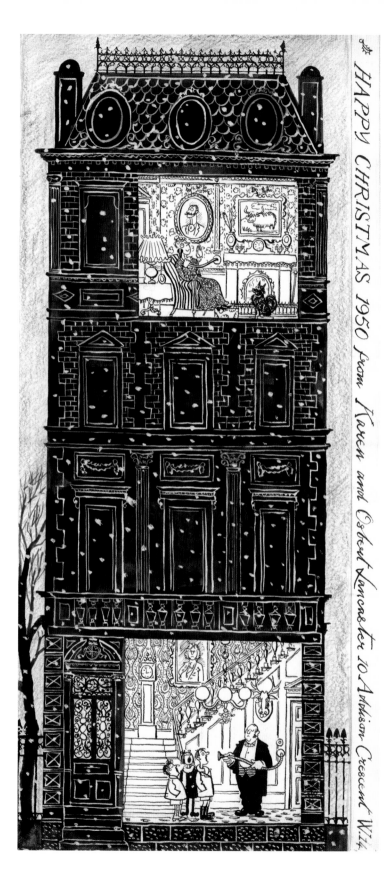

HAPPY CHRISTMAS 1950 from Karen and Osbert Lancaster 10 Addison Crescent W14.

Artwork for Osbert's Four
seasons' Christmas card

clockwise from top: Winter,
Spring, Summer, Autumn.

'*Here beginneth a Merry Christmas*' (1960)

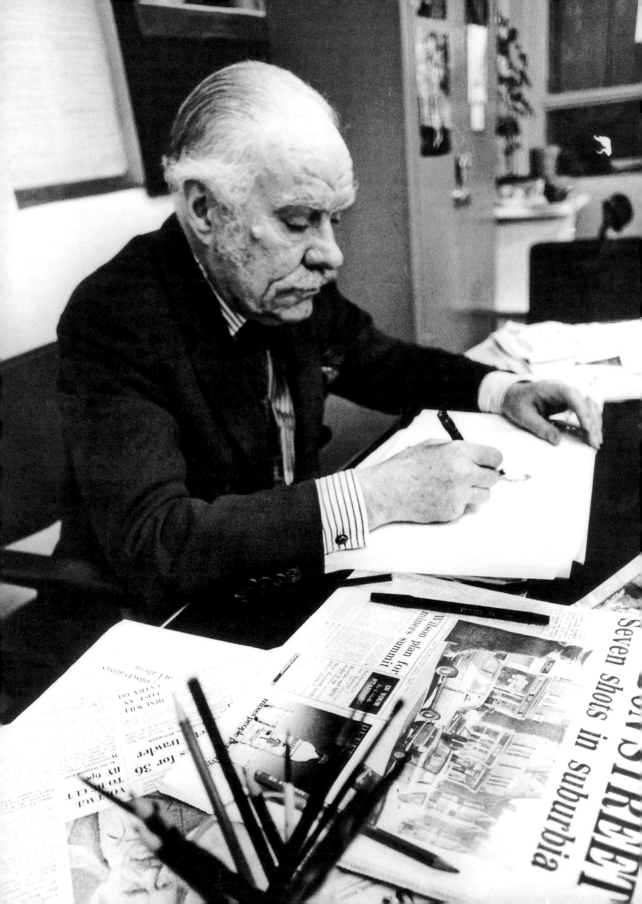

CARTOONS

Towards the end of 1938, Osbert was chatting with his friend, John Rayner, features editor of the *Daily Express* when he mentioned his admiration for 'the little column-width cartoons' published in the French papers. 'Go ahead,' was Rayner's instant reaction, 'give us some.' On 1 January 1939 the first ever pocket cartoon, so called after the pocket battleships much in the news at the time, was launched in the English press. Apart from an eighteen-month break due to wartime service in Greece, Osbert was to produce a pocket cartoon in the *Daily Express* almost every day for the next forty years.

Osbert's facility, which was grounded in his early training in the Studio at Charterhouse and the life class of the Byam Shaw School of Art, was first recognized at Oxford, where he produced a steady flow of caricatures, illustrations and cartoons for the undergraduate weeklies. Thereafter his talent lay dormant while other artistic goals were pursued but it sprang to life, fully formed, at John Rayner's inspired suggestion.

His wartime output turned the Germans into hapless figures of fun, whether they were Marshall Goering with his 'never receding girth' or, at the time of gravest danger, German parachutists and undercover agents. So deadly was his wit that booklets of his cartoons were dropped over Germany and occupied countries with the captions translated into the appropriate languages. On the home front Osbert's impact on morale was saluted by Anthony Powell who wrote that he 'kept people going by his own high spirits and wit'.

Following the war his fame grew and along with it the cast of characters who spoke for him, led by the indomitable Countess of Littlehampton, known as Maudie. 'Having started as a slightly dotty class symbol', he admitted, 'she's been increasingly useful as a voice of straightforward comment, which might be my own.'

All facets of Osbert's personality were reflected in his genius as a cartoonist. His tough wartime experiences informed his sceptical asides on international and domestic crises; his love of *la comédie humaine* drew him irresistibly to the latest headlines on the Permissive Society; and his passion for architecture honed his barbs aimed at developers and planners. Osbert wrote: 'It is not the cartoonist's business to wave flags and cheer as the procession passes; his allotted role is that of the little boy who points out that the Emperor is stark naked.'

Osbert drawing one of his daily Pocket Cartoons at the *Daily Express*

A selection of jacket artwork for his collections of pocket cartoons which had been the brainchild of Jock Murray at the height of the blitz. A staple of the Murray's Christmas list, the first volume appeared in November 1940 and the last in 1979.

'So you're the new secretary of our local branch of the Society for the Abolition of Blood Sports.' (6 February 1949)

'...and so her two repressed and emotionally unfulfilled elder sisters forced poor little Cinderella to conform to the behaviour pattern of a socially underprivileged domestic worker.' (25 November 1952)

'International relations couldn't be worse? Nonsense! Just you wait till the Olympic Games get started.' (23 January 1948)

'Speaking purely personally, Littlehampton, I consider it rather late in the day for any of our family to start having scruples about capital punishment.' (4 June 1948)

'I assure you, my dear Flora, that the moment he opened his mouth I realised he was an American!' (2 July 1952)

'May I remind you my good man, that you are living in a smokeless zone.' (21 December 1963)

'Well, grandpa, just try and imagine a sort of magic-lantern.' (21 November 1953)

'Now don't get too far ahead of the tea-trollies and please remember that all protests must be shouted in triplicate.' (14 May 1968)

'I wonder if you could tell us whether Indian hemp is an annual or a perennial?' (27 May 1966)

'Just as I thought – simply a prestige symbol!' (24 April 1969)

'Please might I borrow one just for half-an-hour for demonstration purposes?' (16 October 1968)

'Of course the tourist figures are falling! What American in his senses is going to pay out good money to come over and see a fourth-rate mini-Manhattan?' (15 September 1972)

'Well, actually we're stifling our burning
resentment of social injustice until the
tele-cameras come along.' (2 May 1969)

'As I see it, the genetic breakthrough
may well mean the end of the sturdy
individualist.' (26 November 1969)

'And what's more, dear boy, I
understand that she's self-employed
and zero rated!' (1 November 1972)

'I suppose you realise that we've
also achieved freedom from cash!'
(11 June 1969)

'Papa!!!' (23 June 1964)

'One hardly knows what to believe – one moment they say gooseberry bushes and the next, test tubes.' (16 January 1958)

'– and that, dear children, is what comes of pre-marital intercourse!' (5 September 1963)

'The Holy Father's quite right – it doesn't work!' (censored and not printed)

'Now, before we go any further, could we please get it quite clear which side of the fence we are, individually, on?' (15 October 1969)

'*Cher Monsieur Wilson – C'est avec des regrets les plus sincères que …*' (3 May 1967)

'*If you ask me it won't be the Daily Express or General de Gaulle who'll keep us out of Europe, but the Rolling Stones!*' (14 April 1967)

'*My name is Ozymandias, King of Kings, look upon my works, ye mighty, and despair.*' (14 March 1967)

The King who couldn't make it.
(24 December 1956)

Osbert loathed all forms of political oppression. It fuelled his biting caricatures of the Nazis as well as his efforts to sway opinion against the attempted communist takeover of Greece. Similarly, he refused to set foot in the country (at great personal sorrow) during the dictatorship of the Colonels (1967–74).

'How on earth do the Board of Trade expect a small private firm like ours to maintain output if we have to waste valuable time answering damnfool questionnaires?' (6 March 1948)

'Branch secretary, Musicians Union speaking. Remember! No prestissimos while the Go-Slow's on.' (29 June 1968)

'Am I correct in assuming that membership of the Common Market will entitle this country to the free and unrestricted use of the guillotine.' (10 October 1961)

'Lord Hengiest wants to know what steps are being taken by Her Majesty's Government to protect the interests of the Anglo-Saxon minority.' (31 October 1968)

'If my amendment had been carried, the act would have been made retrospective!' (25 October 1967)

'And it came to pass in those days there went out a decree from Caesar Augustus that all the world should be taxed … Plus ça change, plus ça la même chose.' (23 December 1967)

'All over the country the grime, muddle and decay of our Victorian heritage is being replaced and the quality of urban life uplifted!' – Harold Wilson. (5 October 1967)

'No Cabinet this morning, gentlemen – we're too busy blame-shifting.' (15 April 1967)

'If only the docks were working, and if only the Suez Canal was open, and if only we had after-sale service and a few spare parts this model would close the trade-gap single-handed!' (17 October 1967)

'From Greenland's icy mountains / To far Korea's strand / I think the U.S. forces / Are getting out of hand ... ' (26 January 1968)

'We'll keep (with the continued assistance of the International Monetary Fund) the Red Flag flying high!!' (4 October 1969)

'According to Mr Wilson its the sweet smell of success which attracts all these foreign tourists to Labour London.' (1 October 1969)

'Mais, dis moi cheri, qu'est que c'est ce
Think Tank?' (4 August 1977)

'Tell me, I never know, is 'Quango' an
unmentionable disease or a People's
Republic?' (25 May 1979)

'Listen to the Minister – If you
don't get satisfaction write to the
appropriate government departments!'
(13 September 1966)

'The lay public must be made to realise
one gets no place without taking risks!'
(30 March 1954)

'Turn left where it says "no cigarettes", keep straight on past wot used to be the petrol pump till you sees a notice saying "no admittance by order of the War Office" and that's the old Elizabethan Manor 'Ouse.' (25 August 1948)

'Because they were very unhealthy and kept out the glorious sunlight – that's why!!' (12 March 1954)

'At the Ministry, fortunately, we have no problem with the dustmen's strike – all our rubbish is filed.' (5 November 1970)

'Good heavens! We must be in the Green Belt.' (3 February 1965)

'Now, perhaps you'll believe me when
I tell you that our beaches are so clean
you can eat off them!' (12 January 1967)

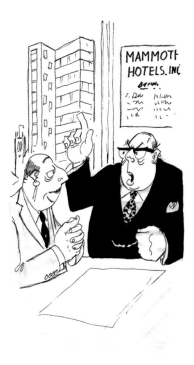

'Gentlemen, let us get our priorities
right. Historic buildings must not be
allowed to stand in the way of expensive
accommodation for the tourists who
come to see these historic buildings!'
(17 October 1969)

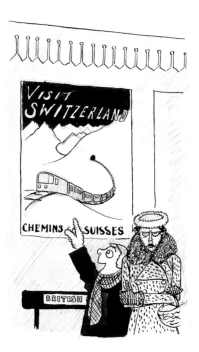

'Look, Mummy! Trains which work in
the snow!!' (no recorded date)

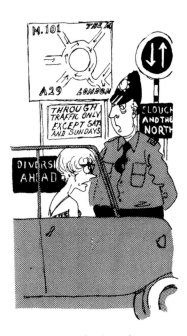

'Can't you read?' (6 July 1976)

'Anybody here from MI5 ... Anybody here from MI5?' (28 March 1940)

'It says: "Half a mile to the W. of church (13th cent. fine glass – key with verger) is the old castle. Entrance 6d. Children 3d. Open 9–6, May–Sept, 10–4 Nov–April. Well worth a visit".' (3 September 1940)

'Crackenthorpe always believes in making the most of his opportunities.' (7 March 1941)

WAR
These cartoons appeared under the pseudonym
of Bunbury in the Sunday Express

(9 April 1944)

'You are requested to remain in your
seat until the end of the performance.'
(1 August 1943)

'Sorry, I was a stranger here myself.'
(24 October 1943)

'Extraordinary the way these painter-fellers seem to be able to work entirely from memory.' (5 May 1943, during food rationing)

'If anyone ever asks you about that picture just remember its a portrait of my dear old mother.' (7 January 1943, during the period when the Nazis were looting works of art)

'Every night I hear the BBC say that we Germans listen regularly to foreign broadcasts – personally I don't believe a word of it. Heil Hitler.' (6 May 1943)

DIVERSION
UNEXPLODED
BOMBS

reprinted from the "Daily Express"

BY OSBERT LANCASTER

SOURCES

All the illustrations come from private collections with the following exceptions:

From the Glyndebourne Archive
(with special thanks to Julia Aries, archivist)

Photographs of *Falstaff* (p.134–5)

Design for *Falstaff* Act 2 scene 2 (p.135)

Costume designs for *Falstaff* (p.136)

The Rising of the Moon backdrop (p.142)

The Rising of the Moon: Mrs Jowler (p.142)

Nicholas Maw, Osbert and Colin Graham (p.142)

L'Italiana in Algeri: The Palace of the
Bey of Algiers [photo] (p.146)

L'Italiana in Algeri: Mustapha and Elvira (p.147)

The Rake's Progress: Brothel dancers (p.148)

The Rake's Progress: Tom Rakewell (p.149)

Glyndebourne Audience (p.150)

From the Royal Opera House Collections
(with special thanks to Julia Creed, archivist)

Coppelia Act 2 [photo] (p.139)

Bonne Bouche: The heroine and her
mother [photo] (p.145)

Bonne Bouche Act 1 scene 1 [photo] (p.145)

**From *All's Well that Ends Well*,
Folio Society edition, 1963**

Florence, Lavache and French Lords (p.143)

BOOKS BY OSBERT LANCASTER

Progress at Pelvis Bay (1936)

Our Sovereigns (1936)

Homes Sweet Homes (1939

Classical Landscape with Figures (1947)

The Saracen's Head (1948)

Drayneflete Revealed (1949)

Façades and Faces (1950)

All Done from Memory (1953)

Here of All Places (1959)

With an Eye to the Future (1967)

Sailing to Byzantium (1969)

The Littlehampton Bequest (1973)

A Cartoon History of British Architecture (1975)

The Pleasure Garden [with Anne Scott-James] (1977)

Scene Changes (1978)

COLLECTIONS OF POCKET CARTOONS

Pocket Cartoons (1940)

New Pocket Cartoons (1941)

Assorted Sizes (1944)

Further Pocket Cartoons (1942)

More Pocket Cartoons (1943)

More and More Productions (1948)

A Pocketful of Cartoons (1949)

Lady Littlehampton and her Friends (1952)

Studies from the Life (1954)

Tableaux Vivants (1955)

Private Views (1956)

The Year of the Comet (1957)

Etudes (1958)

Signs of the Times: 1939–61 (1961)

Mixed Notices (1963)

Graffiti (1964)

A Few Quick Tricks (1965)

Fasten your Safely Belts (1966)

Temporary Diversions (1968)

Recorded Live (1970)

Meaningful Confrontations (1971)

Theatre in the Flat (1972)

Liquid Assets (1975)

The Social Contract (1977)

Ominous Cracks (1979)

The Life and Times of Maudie
Littlehampton: 1939–80 (1982)